THE BEST OF

colored pencil

III

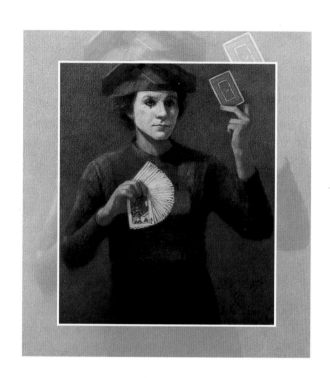

First published in the United States of America by:
Rockport Publishers, Inc.
146 Granite Street
Rockport, Massachusetts 01966-1299
Telephone: (508) 546-9590
Fax: (508) 546-7141

Distributed to the book trade and art trade in the United States by:
North Light, an imprint of
F & W Publications
1507 Dana Avenue
Cincinnati, Ohio 45207
Telephone: (513) 531-2222

Other Distribution by:
Rockport Publishers
Rockport, Massachusetts 01966-1299

ISBN 1-56496-209-1

10 9 8 7 6 5 4 3 2 1

Art Director: **Lynne Havighurst**
Designer: **Sara Day Graphic Design**
Cover Illustrations: (FRONT) **Linda M. Miller**

Manufactured in Singapore by Regent Production Services Pte. Ltd.

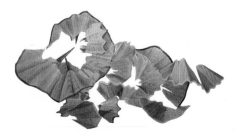

THE BEST OF

colored pencil

III

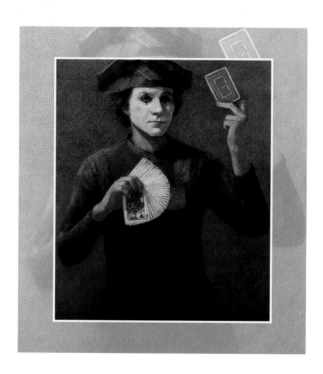

ROCKPORT
PUBLISHERS

ROCKPORT PUBLISHERS, ROCKPORT, MASSACHUSETTS
DISTRIBUTED BY NORTH LIGHT BOOKS, CINCINNATI, OHIO

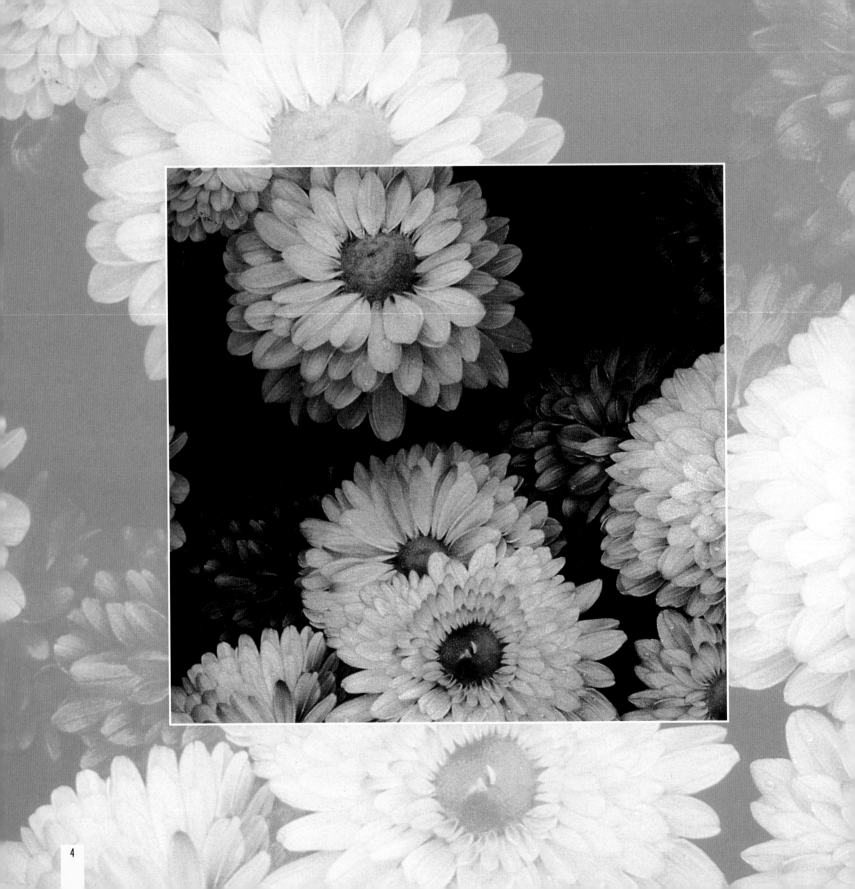

foreword

I admit it. I used to be one of those who never gave much thought to colored pencil as an artform. A colorful sketching medium, perhaps...A kids' art tool, for sure...Nothing more. But it wasn't far into my seven-year tenure with the *Artist's Magazine* that my eyes were opened to the tremendous versatility, complexity, and beauty of colored pencil art.

Though I see thousands of artworks every year, I'm still surprised sometimes by colored pencil work. In the hands of different artists it has so many faces. I may think a piece is pastel or gouache, acrylic or even oil, only to marvel at the discovery that it's colored pencil.

Amy Lindenberger, President of the CPSA Cleveland District Chapter, tells a delightful story that reveals how much we all still have to learn about colored pencil: At a local art show, she overheard a bystander commenting on her work, saying, "I know it says colored pencil, but it's not, because I have colored pencils at home, and they don't do that!"

Amy's story highlights the importance of educating the public about the artistic strength of colored pencil. Since its formation in 1990 by founder Vera Curnow, the Colored Pencil Society of America has made great strides in this direction. I'm proud to be part of a publication like the *Artist's Magazine* that continues to provide exposure for colored pencil artists and to encourage others to try this expressive medium.

The works appearing in the CPSA annual exhibitions are a testament to the creative possibilities of this deceptively simple medium. This book, too, goes a long way toward exposing the public to the artistry of colored pencil. The works featured in the following pages reveal the amazing range of effects possible with such a seemingly mundane art tool—everything from soft, subtle shadings to intensely colored and burnished passages. Styles range from the cartoonish look of the purely whimsical to the richly human aspect of serious portraiture to the imaginative and challenging face of abstraction. As with any medium, colored pencil artists aren't characterized by any particular style or subject matter. They "joyfully" tackle a full range of artforms, and if anything characterizes their work, it's the passion and dedication to their chosen medium that shines through.

No longer exclusive to the realm of illustration, colored pencil has arrived as a fine art medium—a truth to which this book bears witness. Colored pencil has earned a place in both fields. I applaud the artists who have borne the torch and wish them well as they continue to push the range and acceptance of colored pencil to new heights.

MARY MAGNUS
Editor
The *Artist's Magazine*
Co-Judge, 1995 CPSA International Colored Pencil Exhibition

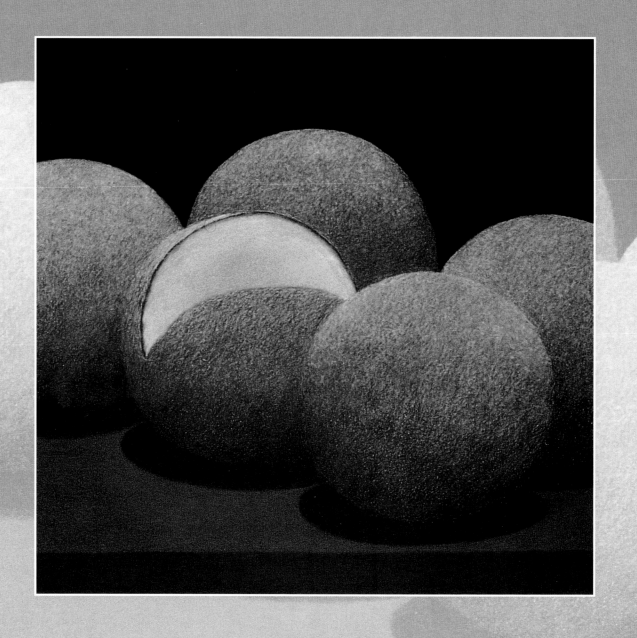

introduction

As the Founder of the Colored Pencil Society of America (CPSA), it is with particular pride that I introduce this diverse cross section of entries to our 1995 International Colored Pencil Exhibition, which was held in Cleveland, Ohio.

Our 3rd annual exhibition marks the first year that exhibiting artists were eligible to earn Signature Membership. This Signature status can only be attained by being accepted into three CPSA exhibitions within a ten year period—no easy task since every year each entry competes with almost 1,000 others. All of the work must be 100% colored pencil with no mixed media allowed. For the first time, sixteen members achieved this status and have earned the privilege of using the CPSA initials after their names.

While special rewards are afforded those singled out as Award Winners and Signature Members, the recognition goes beyond individual achievement. Our applause not only acknowledges the award recipients, it also validates the importance of this medium and elevates all colored pencil artists. Finally, this success is a tribute to the many CPSA member volunteers who work in the shadows of the spotlight—without their efforts there would be no showcase for colored pencil artists.

CONGRATULATIONS 1995 CPSA SIGNATURE MEMBERS

Deane Ackerman	Ann Kullberg
Bonnie Auten	Dyanne Locati
Pat Averill	Paula Madawick
Jeffrey Smart Baisden	Ann James Massey
Joe Bascom	Melissa Miller Nece
Vera Curnow	Terry Sciko
Donna Gaylord	Shelly M. Stewart
Gary Greene	Kenneth L. Zonker

VERA CURNOW
Founder
Colored Pencil Society of America

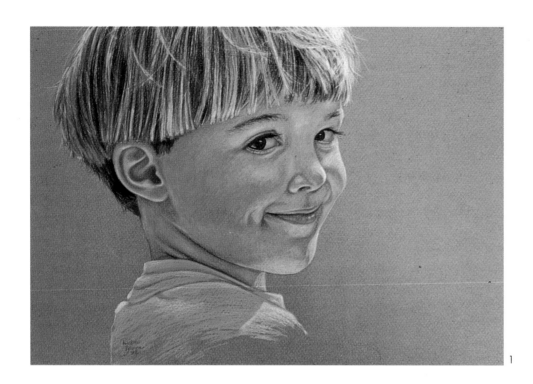

1
Debra Kauffman Yaun
Kevin's Grin
11" x 13" (28 cm x 33 cm)
Pastel paper

2
Dawn Rolland
Marissa
19" x 15" (48 cm x 38 cm)
Strathmore bristol, smooth

3
Carol Baker
Britney
18" x 17" (46 cm x 43 cm)
Bristol 2-ply vellum

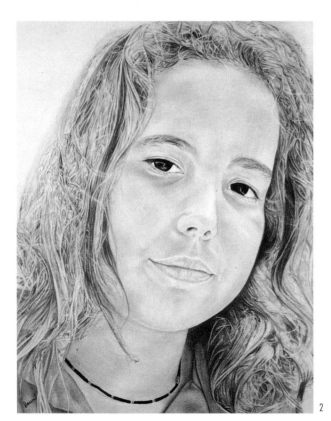

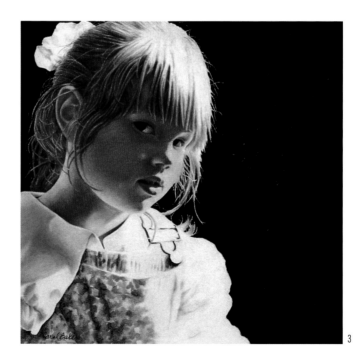

1

Melissa Miller Nece
Signature Member
Tide Pool III
19" x 29" (48cm x 74cm)
Pastel paper

2

Melissa Miller Nece
Signature Member
Headin' In
18" x 24" (46cm x 61cm)
Canson Mi-Tientes

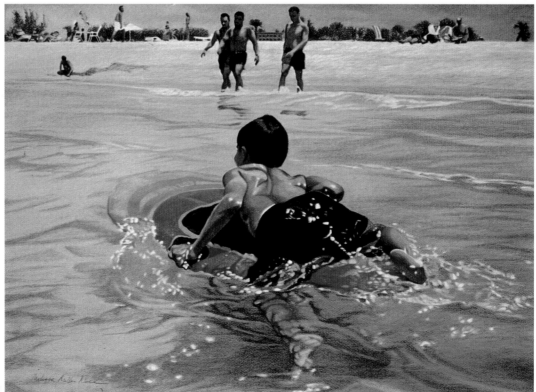

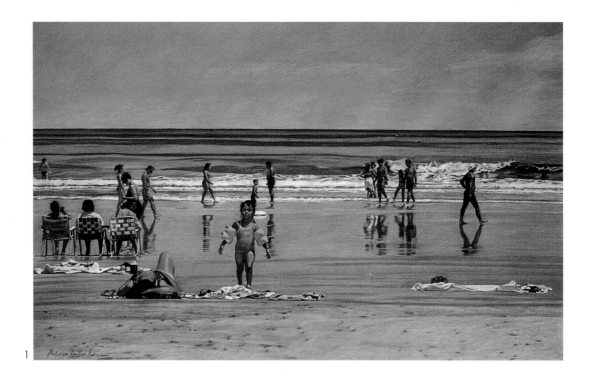

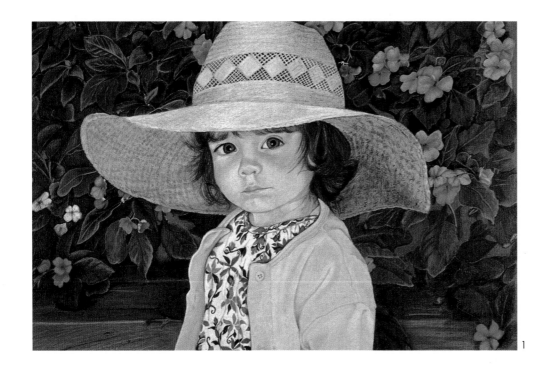

1
Michele K. Blate
Jenna
20" x 26" (51 cm x 66 cm)
Crescent mat board

2
Leslie Roberts
Veronica
18" x 22" (46 cm x 56 cm)
2-Ply bristol

3
Jim Wells
Brandy
22" x 17" (55 cm x 43 cm)
Strathmore bristol board

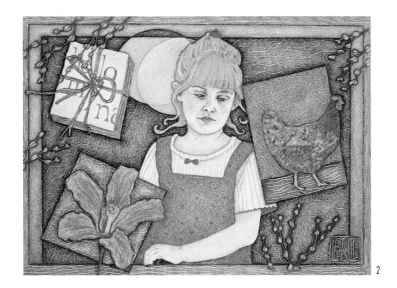

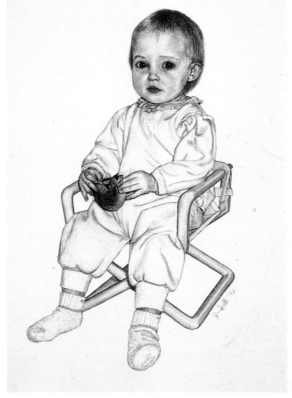

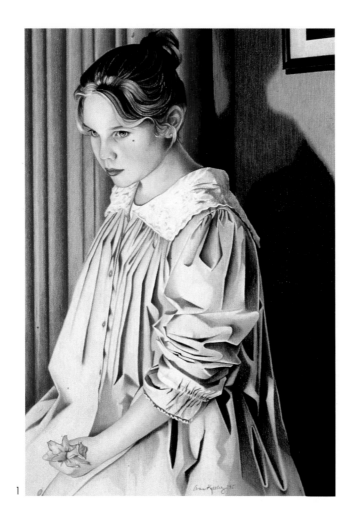

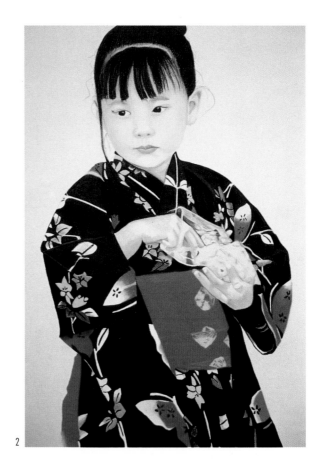

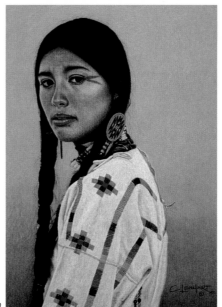

1

Ann Kullberg
Signature Member
Private Room
17" x 11" (43 cm x 28 cm)
Rising Stonehenge

2

Tim Ernst
Popcorn Girl
28" x 19" (71 cm x 48 cm)
Bristol 3-ply vellum

3

Crystal Lenhart
Marzha—Crow Fair 94
22" x 19" (56 cm x 48 cm)
Sandpaper

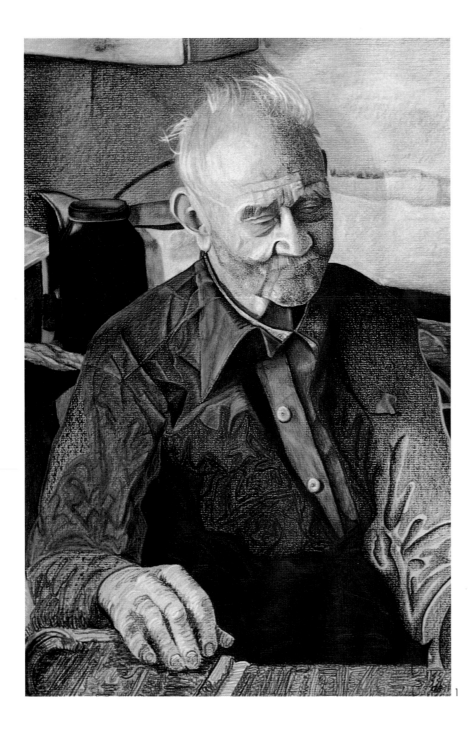

1

Dr. Christine J. Davis
Reflections: Mr. Center
28" x 22" (71 cm x 56 cm)
Strathmore charcoal paper

2

Faith Wickey
Grandma Miller
12" x 9" (30 cm x 22 cm)
Cold press illustration board

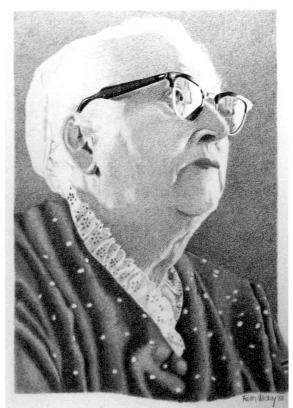

Ann James Massey
Signature Member
Henri Berenger
10" x 8" (25 cm x 20 cm)
Bristol paper

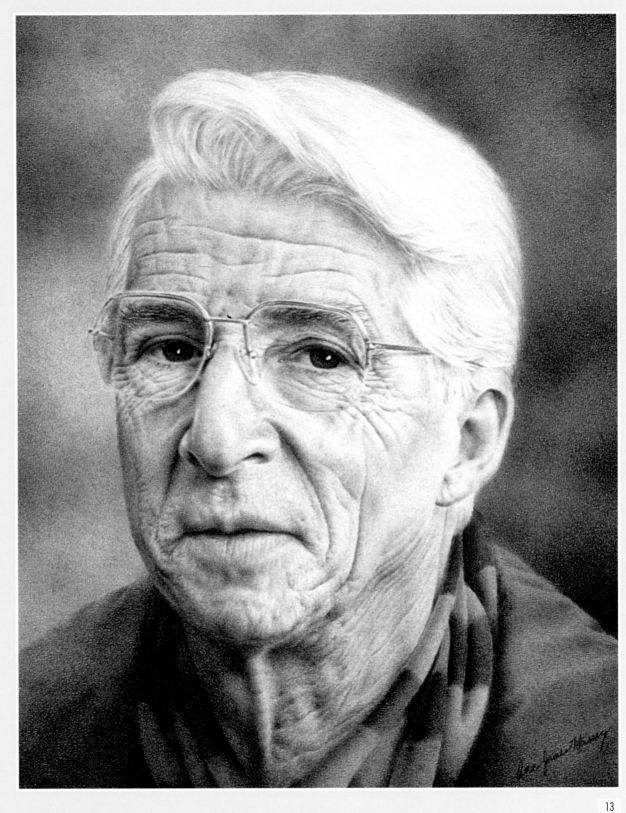

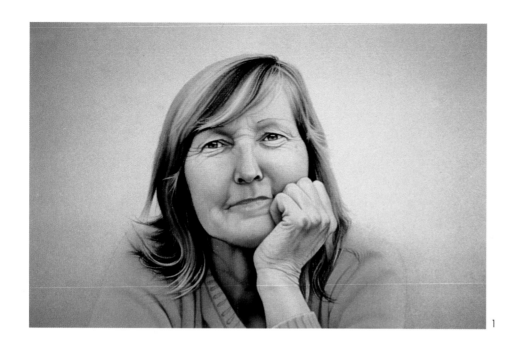

1

Donna Basile
Shirley
16" x 19" (41 cm x 48 cm)
100% rag mat board

2

Dixie Smith
One
27" x 18" (69 cm x 46 cm)
Rising Stonehenge

3

D. J. Hansen
Sunday Afternoon
25" x 19" (64 cm x 48 cm)
Canson Mi-Tientes 98 lb. paper

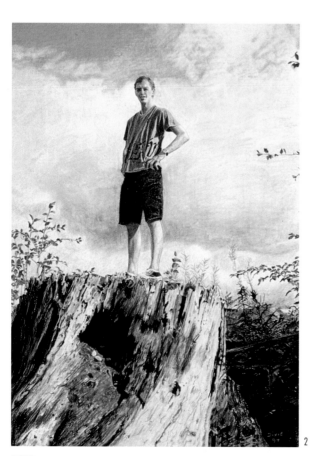

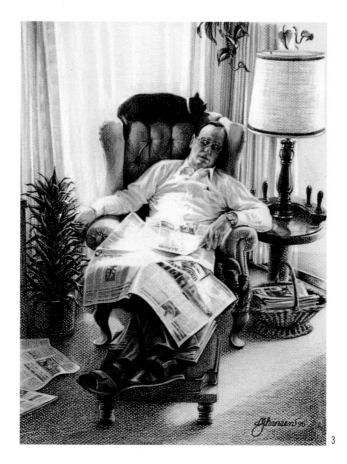

1

Brenda Woggon
The Field Trip
17" x 30" (43 cm x 76 cm)
Windberg art panel

2

Marvin Triguba
Night Watch
21" x 17" (53 cm x 43 cm)
Canson paper

3

Linda Hutchinson
Joy Dance, Boy Dance
40" x 30" (102 cm x 76 cm)
Black illustration board

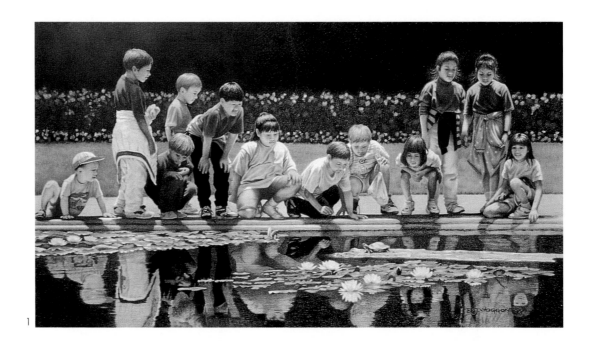

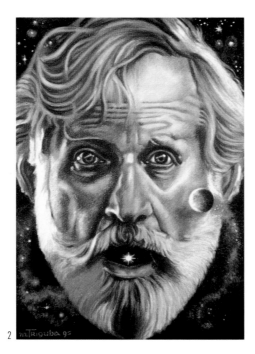

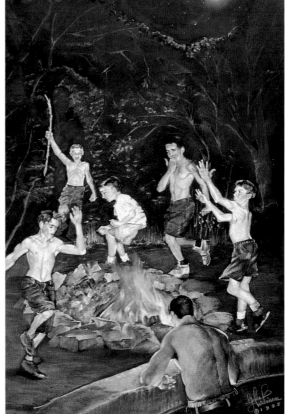

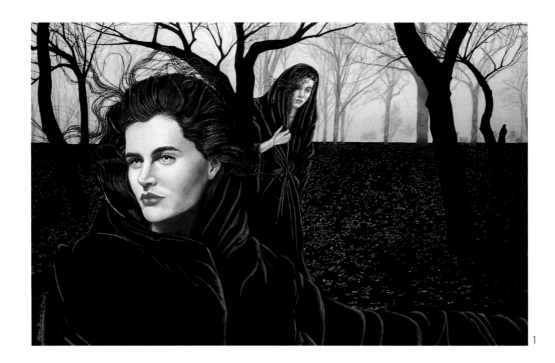

1

Karne Emerald Reeder
Tangled Memories
24" x 32" (61 cm x 81 cm)
Cold press illustration board

2

Robin Shoup
Hope
12" x 15" (30 cm x 38 cm)
Bristol board

3

Cindy Mis Swiech
Sweet Slumber
14" x 14" (36 cm x 36 cm)
Bristol board

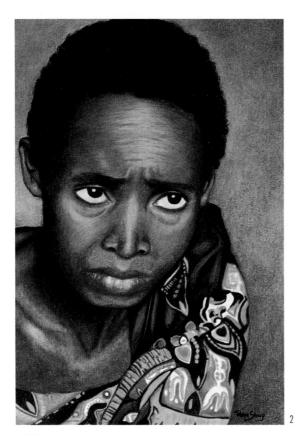

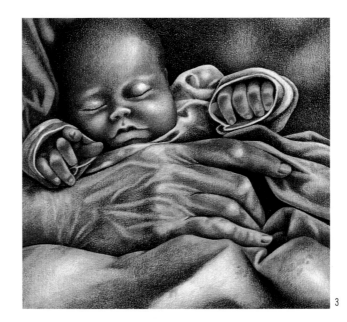

1

Bonnie Auten
Signature Member
Brannon
9" x 13" (23 cm x 33 cm)
Windberg pastel paper, grey

2

Linda Baxter
Rap Star
30" x 24" (76 cm x 61 cm)
Canson paper

3

Debra K. Yaun
Ashley in the Snow
20" x 16" (51 cm x 41 cm)
Pastel paper

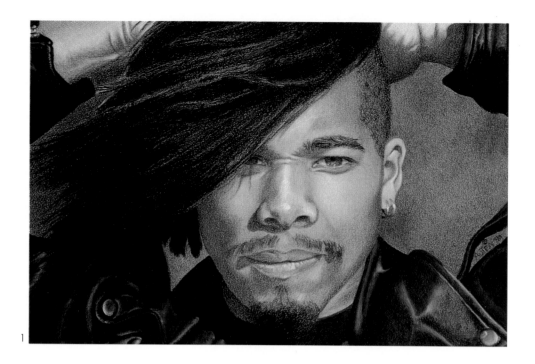

1

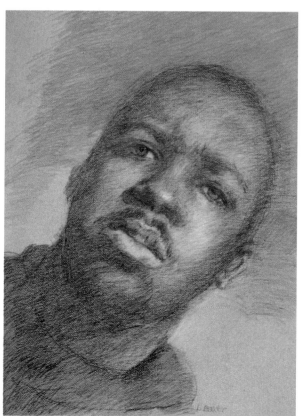

2

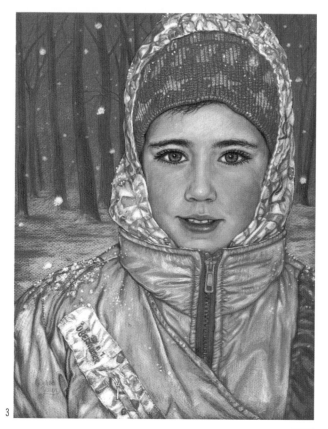

3

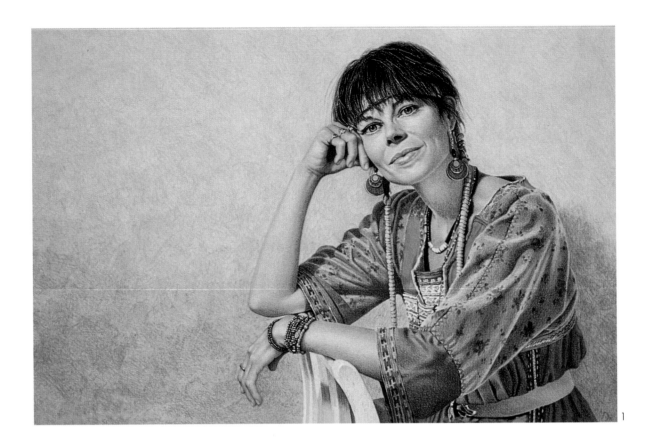

1

Derryl L. Day
Portrait of Hanna
11" x 17" (28 cm x 43 cm)
Cold press illustration board 310

2

Randy Nutter
Naked Innocence
18" x 28" (46 cm x 71 cm)
Crescent mat board

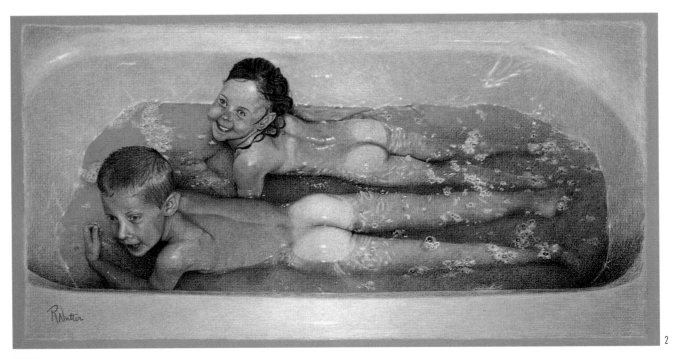

2

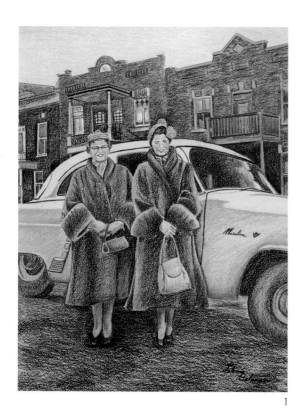

1

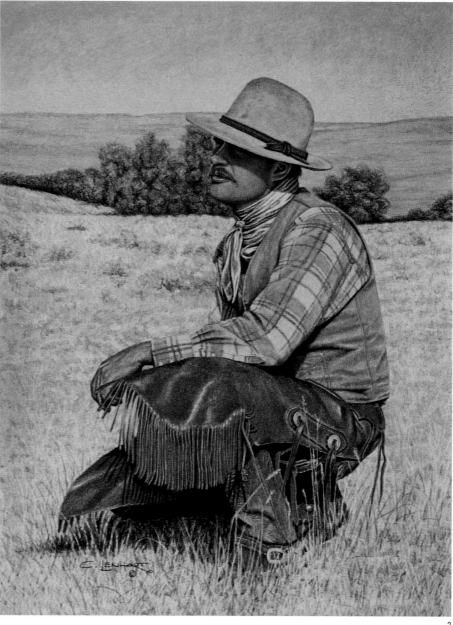

1
Liliane Belanger
Montreal 1953
26" x 20" (66 cm x 51 cm)
Canson Mi-Tientes

2
Crystal Lenhart
I'll Take Wyoming
24" x 20" (61 cm x 51 cm)
Sandpaper

2

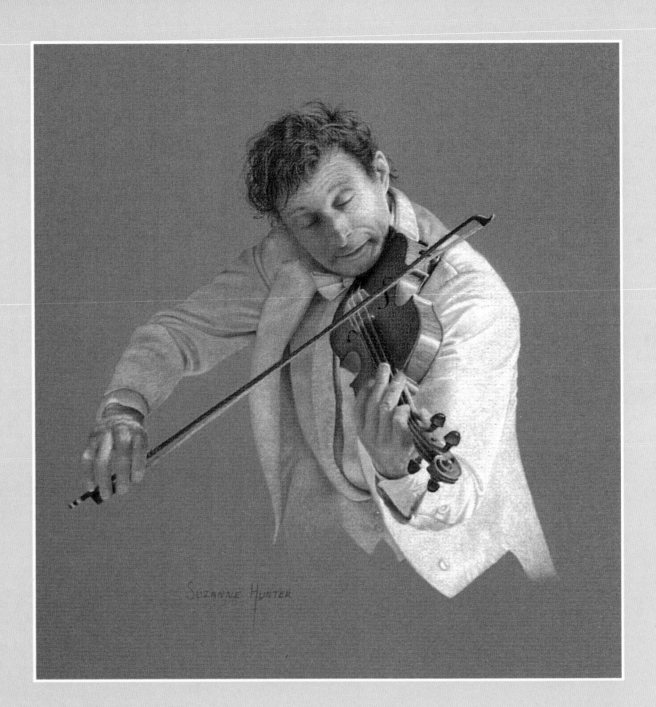

Suzanne Hunter
Ecstasy
18" x 20" (46 cm x 51 cm)
Alphamat

Stanley Pawelczyk
The Old Indian Woman
22" x 20" (56 cm x 51 cm)
Mylar

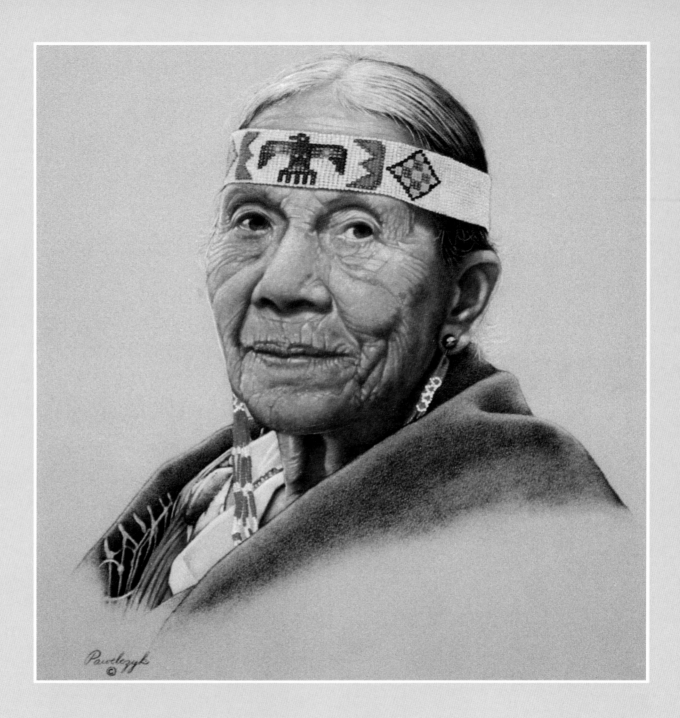

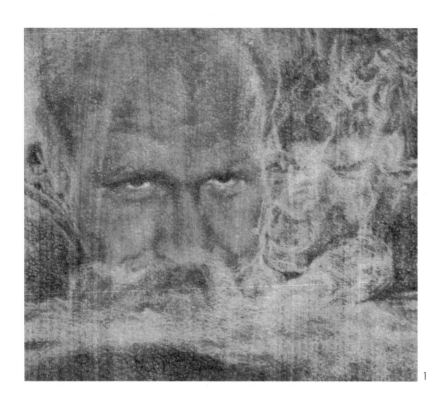

1
Maggie Toole
Sometimes Bob Smokes
31" x 32" (79 cm x 81 cm)
Walnut wood panel

2
Maggie Toole
Full of Sleep and Self Confidence
32" x 24" (81 cm x 61 cm)
Canson Mi-Tientes

3
Nancy Gawron
Brian and the Ball
14" x 17" (36 cm x 43 cm)
Crescent mat board 1605

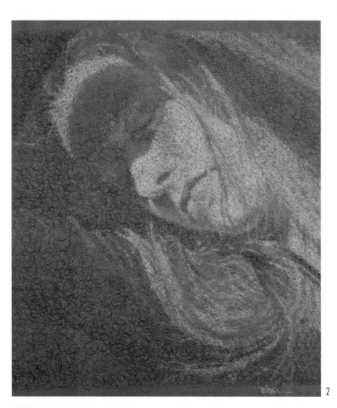

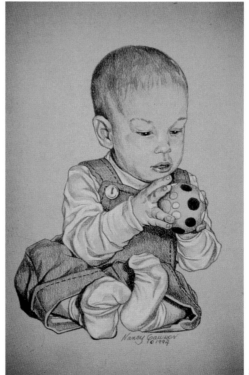

1

Linda Greene
Deep Thought
17" x 23" (43 cm x 58 cm)
Mat board

2

Kenneth Hershenson
Portrait of the Artist
26" x 23" (66 cm x 58 cm)
Rising Stonehenge

3

Tracy D. Snowman
Self-Portrait
22" x 30" (56 cm x 76 cm)
Crescent cold press
illustration board

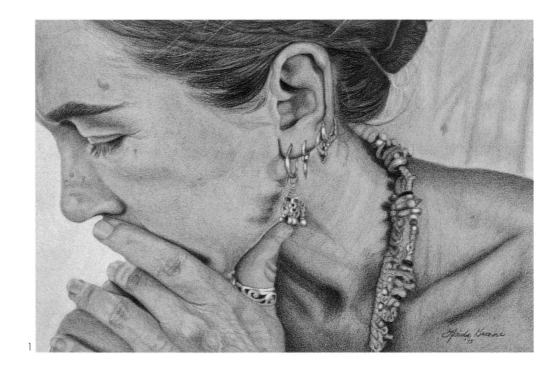

1

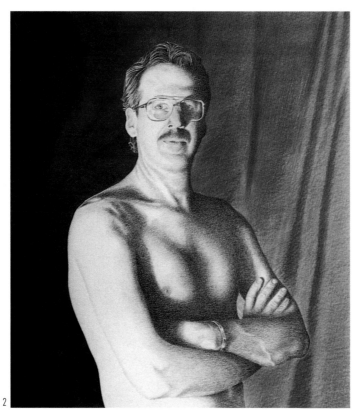

2

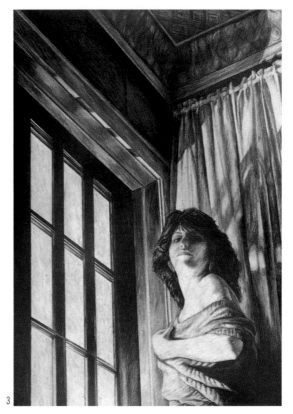

3

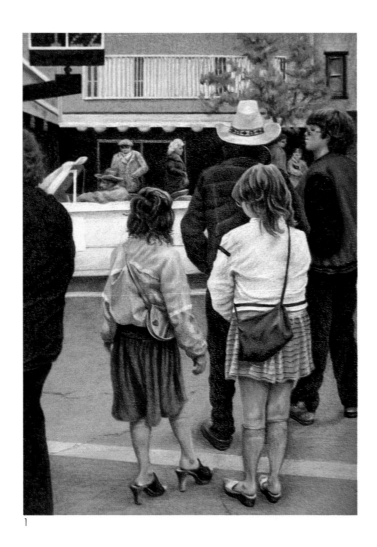

1

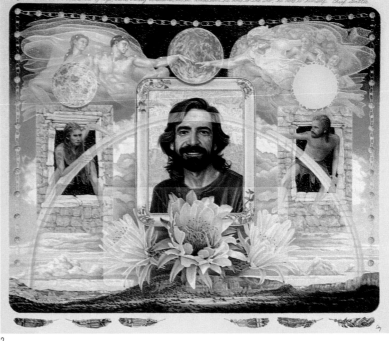

2

1

Dava Dahlgran
Now That's a Classic
20" x 16" (51 cm x 41 cm)
Canson Mi-Tientes

2

Derryl Day
Portrait of Dave
21" x 25" (53 cm x 64 cm)
Cold press illustration board 310

Leslie Cheney-Parr
Male Ritual
24" x 30" (61 cm x 76 cm)
Crane's Rives paper

Susan Mart
Private Places VI
31" x 24" (79 cm x 61 cm)
Medium texture paper

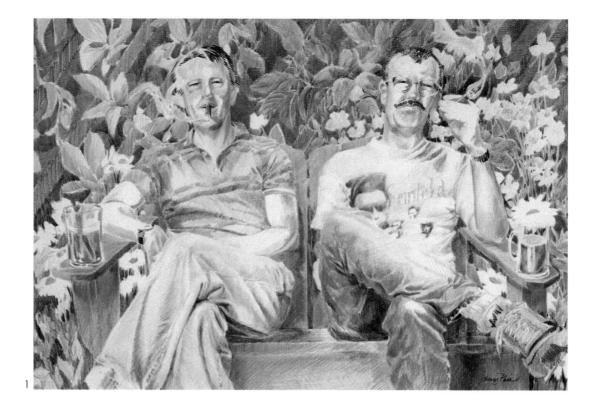

1

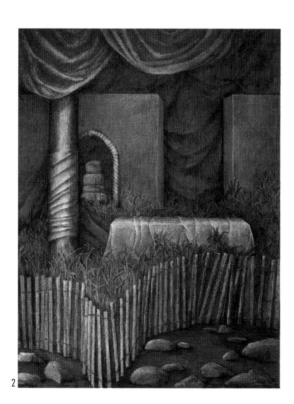

2

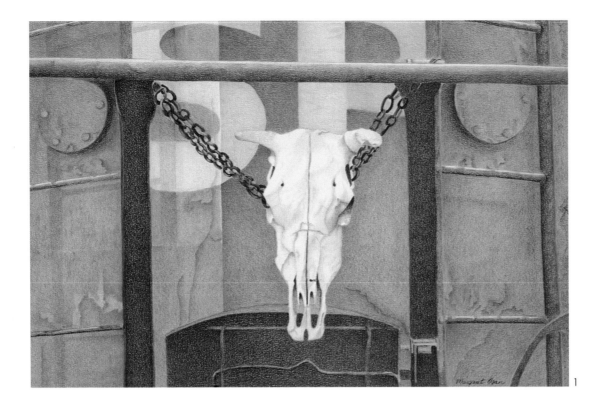

1
Margaret J. Ogan
Up From Arizona
25" x 31" (64 cm x 79 cm)
2-Ply bristol board

2
Elly Sands
The Ancient Ones
33" x 26" (84 cm x 66 cm)
Strathmore hot press illustration board

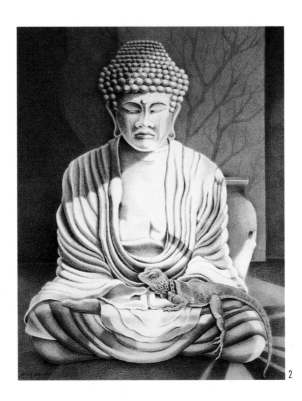

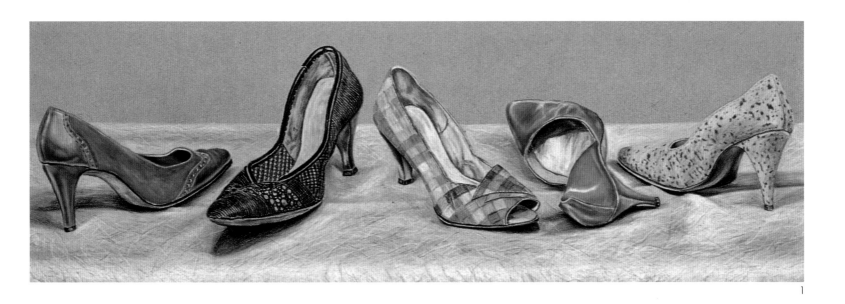

1

Melissa Taylor
All Pumped Up
21" x 36" (53 cm x 91 cm)
60 lb. paper

2

Bonnie Auten
Signature Member
The Anointing
20" x 25" (51 cm x 64 cm)
Windberg pastel paper, dark green

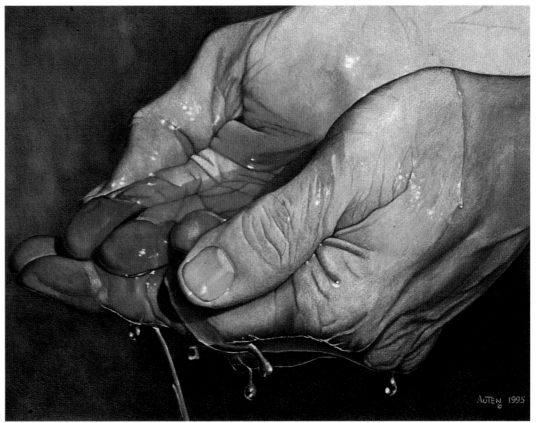

2

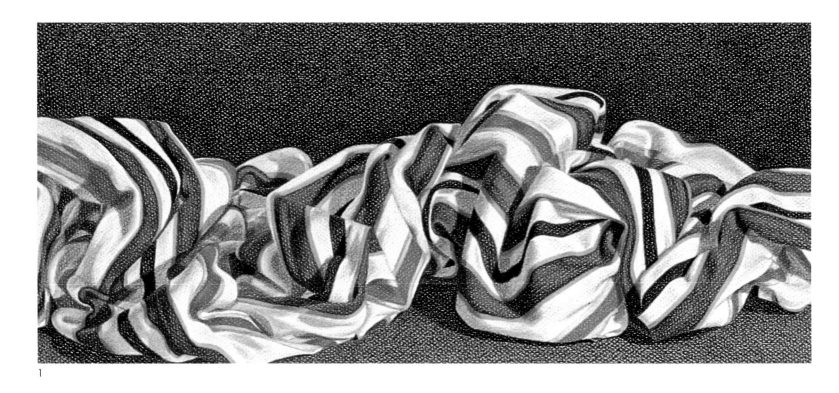

1

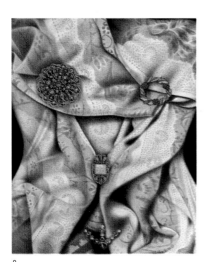

2

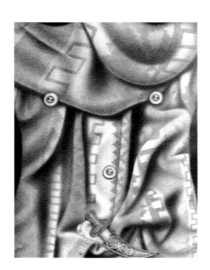

1

Dena V. Whitener
Nolichucky
9" x 20" (22 cm x 50 cm)
Canson Mi-Tientes

2

Jill L. Kline
My Jewels II: She and He
28" x 40" (71 cm x 102 cm)
Bristol board hot press

28

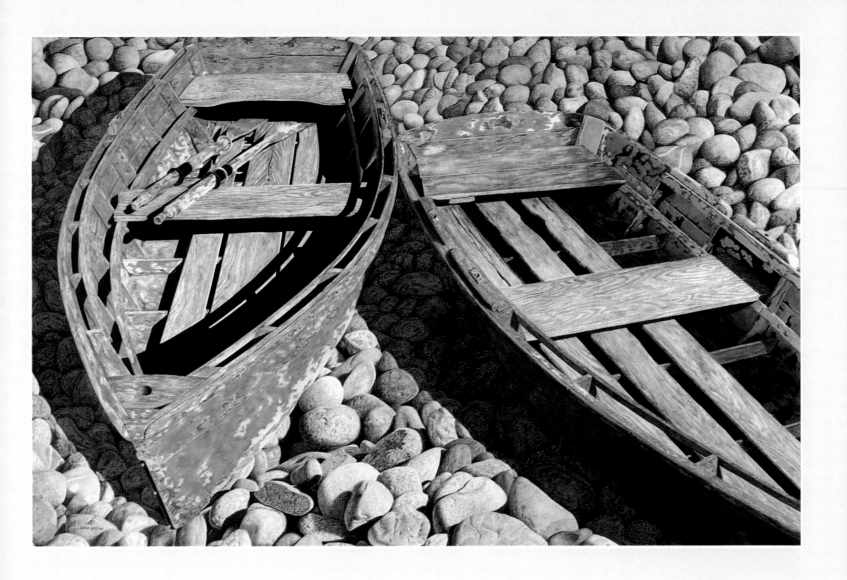

Gary Greene
Signature Member
A Couple on the Rocks
26" x 37" (66 cm x 94 cm)
Strathmore 4-ply museum board

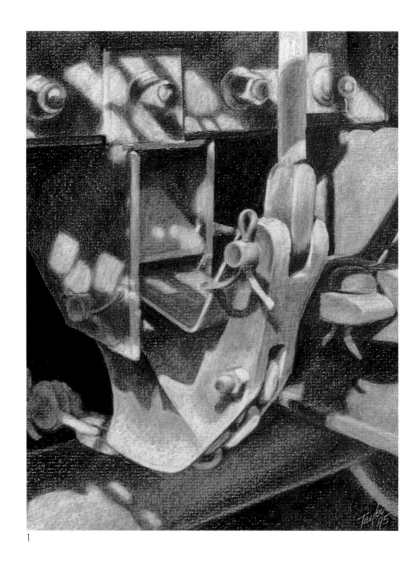

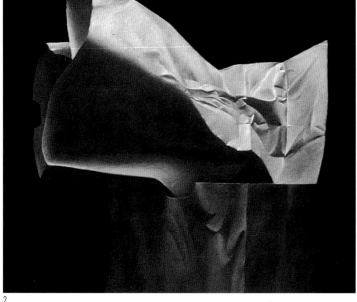

1

2

1

Proctor P. Taylor
Rail Brake
16" x 14" (40 cm x 35 cm)
Strathmore 500 charcoal paper

2

Joe Bascom
Signature Member
Brown Paper Bag No. 94
29" x 35" (74 cm x 89 cm)
Strathmore 2-ply medium

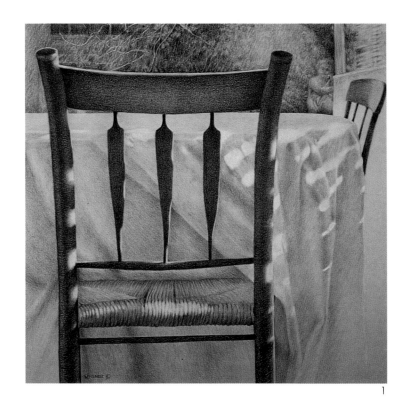

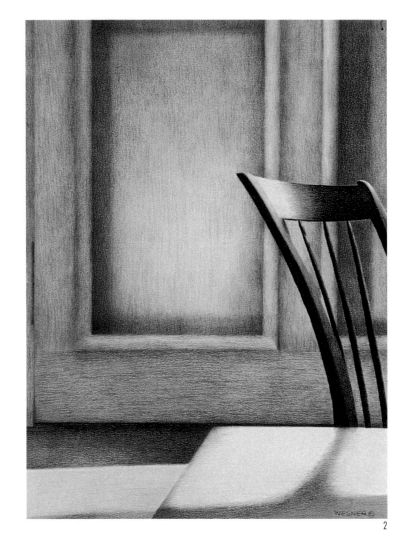

1

Linda Wesner
Traces of Natchez I
24" x 24" (60 cm x 60 cm)
Rising Stonehenge

2

Linda Wesner
Traces of Natchez II
23" x 19" (58 cm x 48 cm)
Strathmore 400 Series bristol board

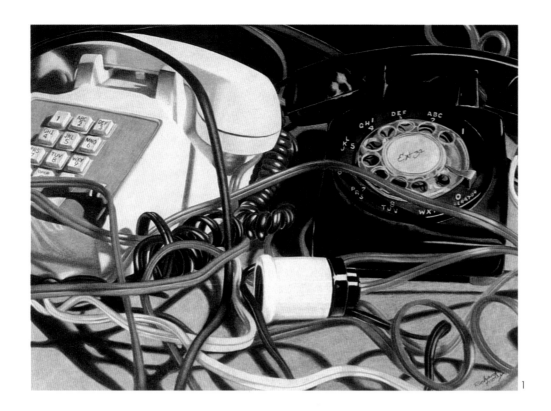

1

Richard Tooley
Extentions
22" x 23" (56 cm x 58 cm)
Crescent hot press illustration board 201

2

Michael Rocco Pinciotti
Feather #17
24" x 36" (61 cm x 91 cm)
Printmaking paper

3

Cynthia Samul
Two Other Kids
13" x 9" (33 cm x 23 cm)
Canson Mi-Tientes

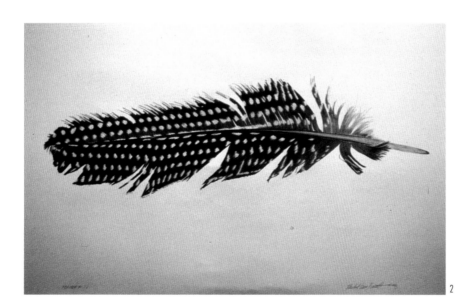

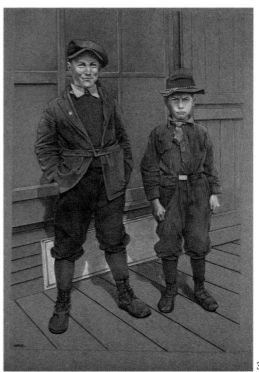

Cynthia Samul
Mac Still on the Job
17" x 10" (43 cm x 25 cm)
Canson Mi-Tientes

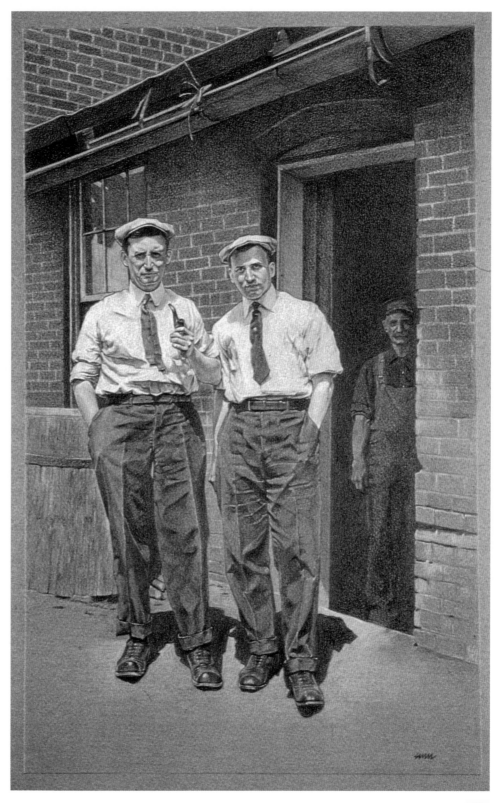

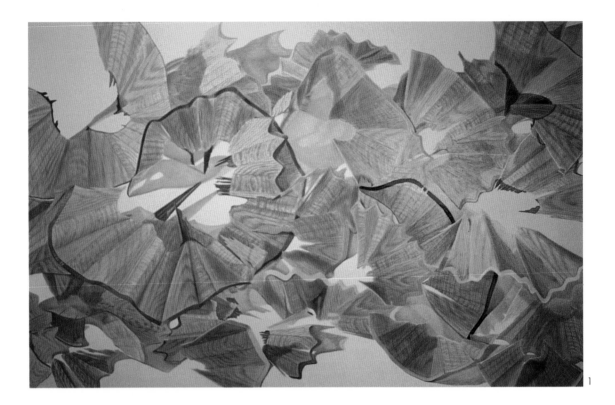

1

Frances Caplan
Pencil Shavings IX
27" x 35" (69 cm x 89 cm)
Strathmore 500 Series plate

2

Christine Wiseman
Red Lanterns
19" x 22" (48 cm x 55 cm)
Museum board

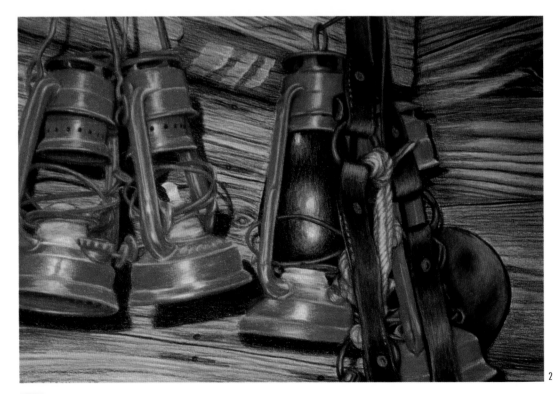

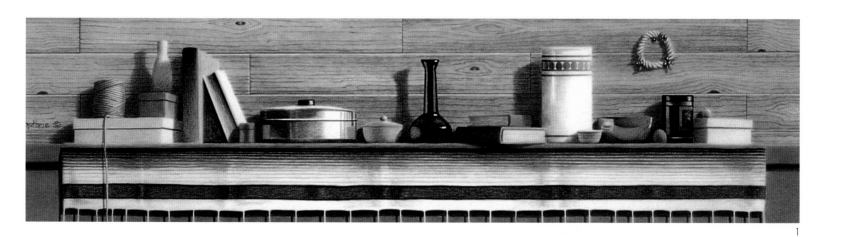

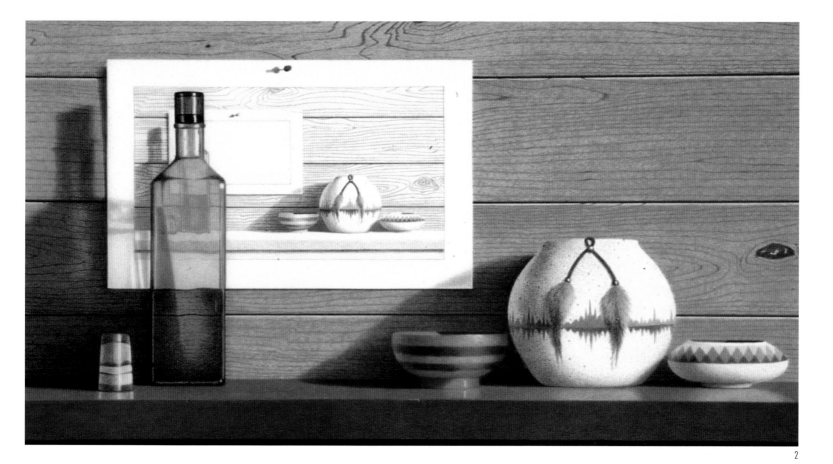

1
Robert Guthrie
Still Life with Serape II
5" x 17" (13 cm x 43 cm)
Mylar

2
Robert Guthrie
Still Life with Pencil Drawing
12" x 22" (30 cm x 56 cm)
Mylar

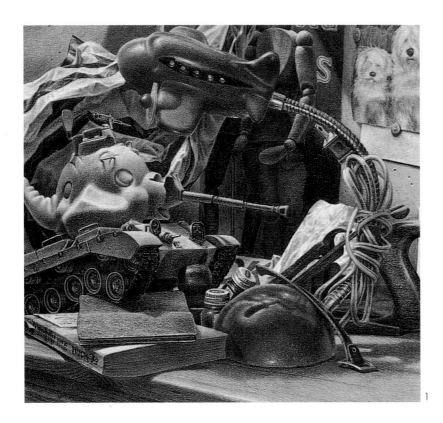

1

Richard W. Huck
Still in the Studio #1
11" x 11" (28 cm x 28 cm)
Arches hot press paper 240 lb.

2

Cheryl Peters
Broken In
25" x 19" (64 cm x 48 cm)
Museum board

3

Anne Renard Smith
The Toy Store
30" x 36" (76 cm x 91 cm)
Arches hot press watercolor

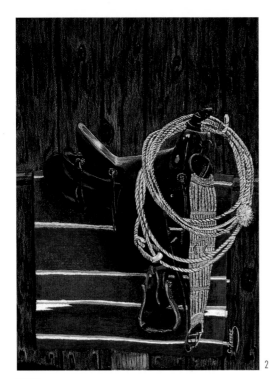

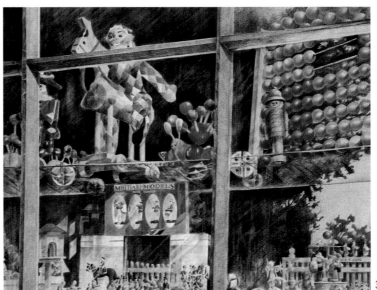

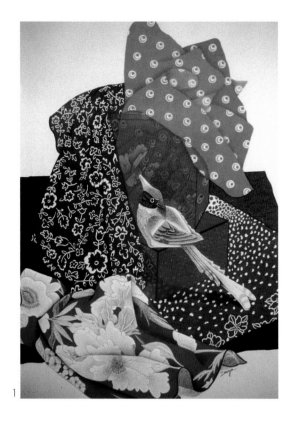

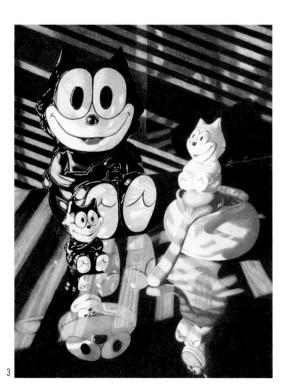

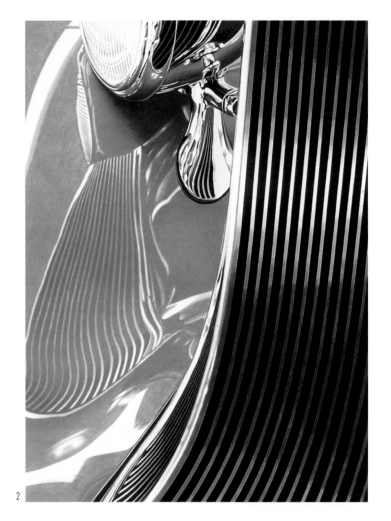

1

Davya Cohen
Gewgaws
37" x 29" (94 cm x 74 cm)
Strathmore 4-ply museum board

2

Gary Greene
Signature Member
'32 Packard
32" x 20" (81 cm x 51 cm)
Strathmore 4-ply museum board

3

Linda Faulkner Robinson
Fun With Felix #1
24" x 19" (61 cm x 48 cm)
Strathmore 500 Series 4-ply

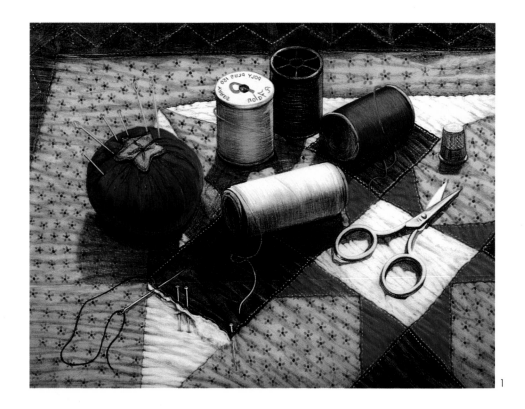

1
Dorris Daub
Mendin' Time
18" x 22" (46 cm x 56 cm)
Mylar

2
Clare Chapman
Suspense
24" x 20" (61 cm x 51 cm)
Bristol 500 Series 4-ply

3
Eileen S. Bell
Art's Fave
14" x 17" (36 cm x 43 cm)
Strathmore 4-ply bristol

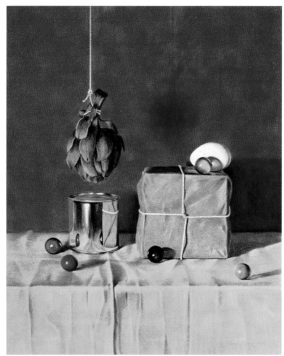

Larry D. Wollam
1910 Nott Fire Engine, Study 1
17" x 11" (43 cm x 28 cm)
Aquabee 2-ply bristol vellum

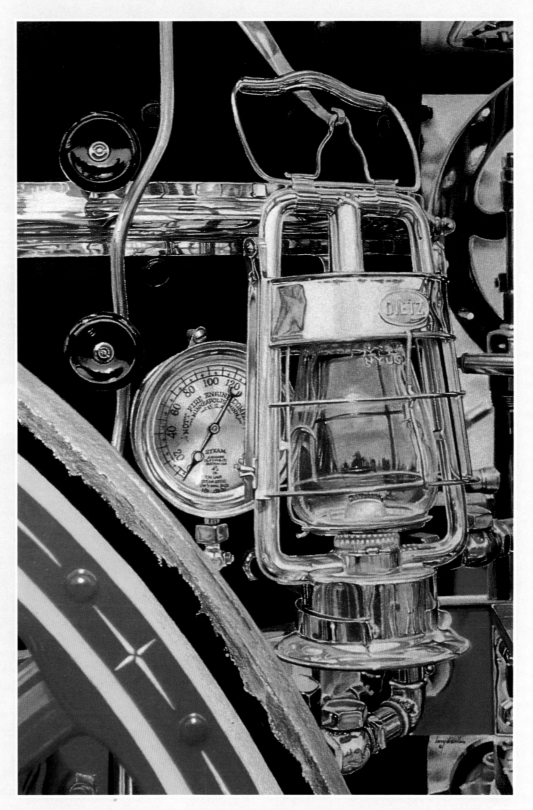

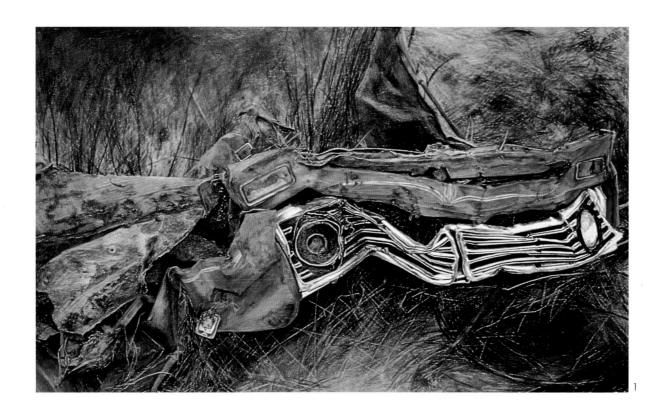

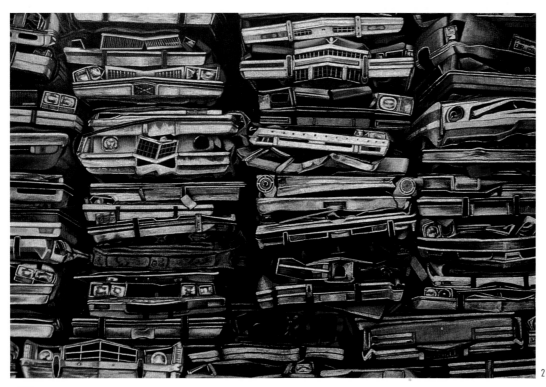

1

Jeffrey Smart Baisden
Signature Member
Southern Totem
32" x 40" (81 cm x 102 cm)
Stathmore museum board

2

Paula Madawick
Signature Member
International #3
13" x 21" (33 cm x 53 cm)
Arches hot press 140 lb. paper

Jim Gerard
Packard Reflections
18" x 24" (46 cm x 64 cm)
Gray charcoal paper

Vivian Mallette Hutchins
New Style
20" x 30" (51 cm x 76 cm)
100% rag board

1

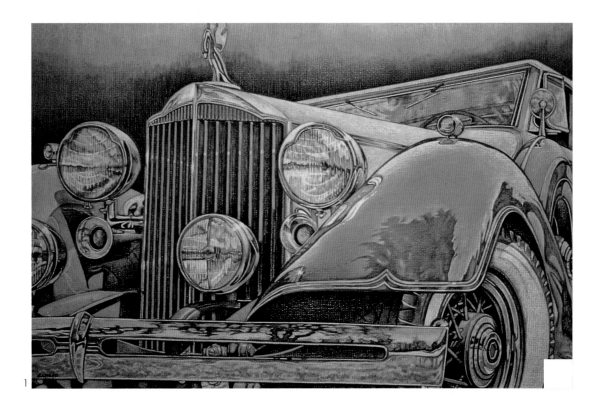

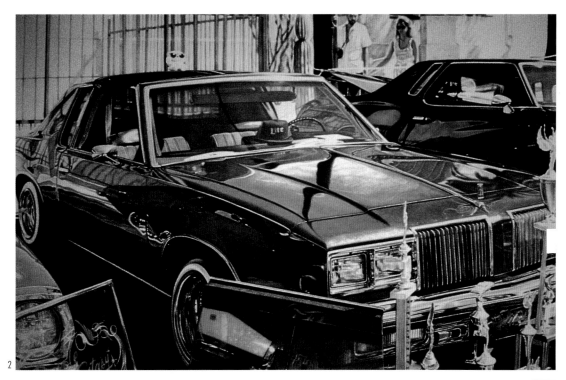

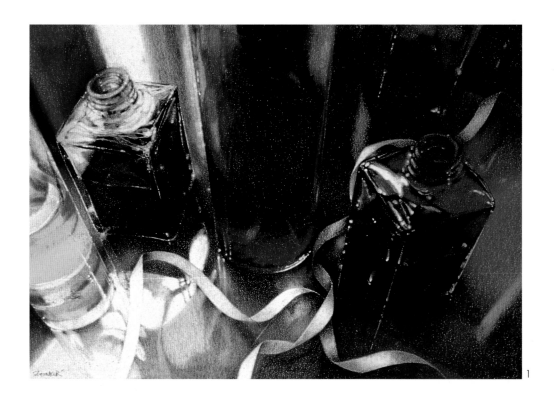

1
Kenneth L. Zonker
Signature Member
View from Above
24" x 29" (61 cm x 74 cm)
Crescent cold press illustration board #110

2
Joanne Smith Wood
Anticipation
19" x 25" (48 cm x 64 cm)
Strathmore 3-ply bristol

3
Cira Cosentino
Baseball Cards
15" x 20" (38 cm x 51 cm)
Canson paper

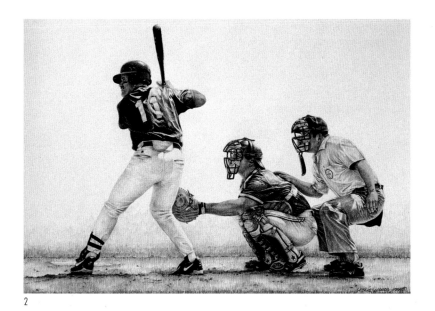

2

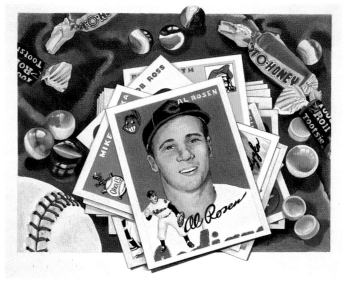

3

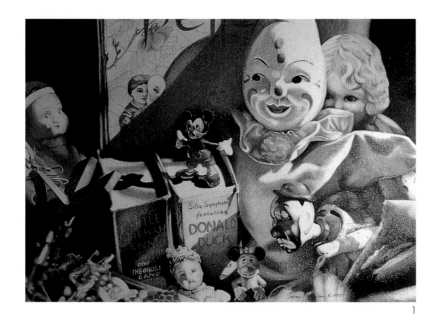

1

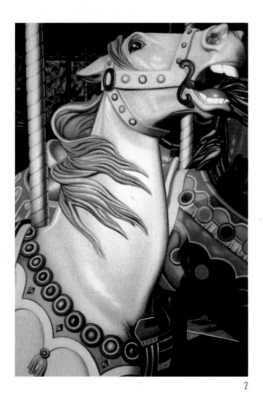

2

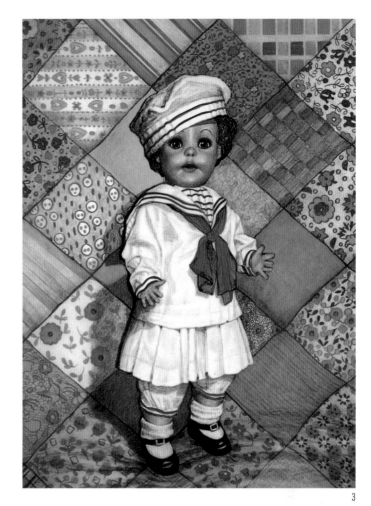

3

1
Susan Kritzberg
The Treasure Box
22" x 28" (56 cm x 71 cm)
Crescent cold press illustration board 300

2
Diane Belfiglio
Illions Horse VI
9" x 6" (23 cm x 15 cm)
Buckeye cover paper

3
Dorris Daub
Hello, I'm Dolly
20" x 15" (51 cm x 38 cm)
Mylar

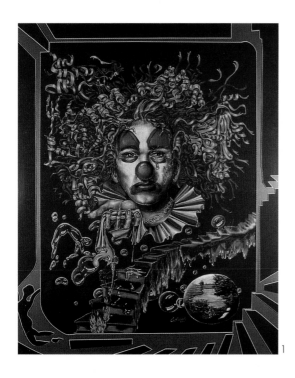

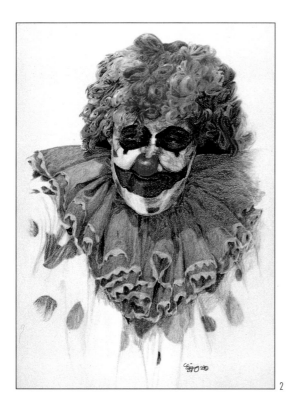

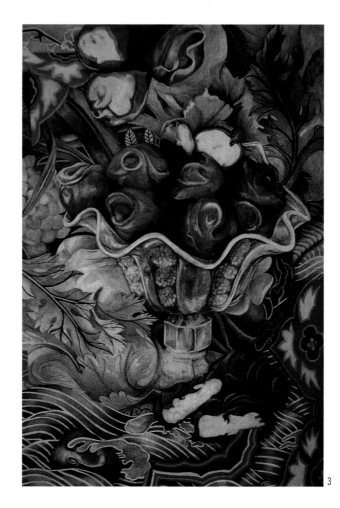

Rita Mach Skoczen
The Card Trick
33" x 26" (84 cm x 66 cm)
Canson Mi-Tientes

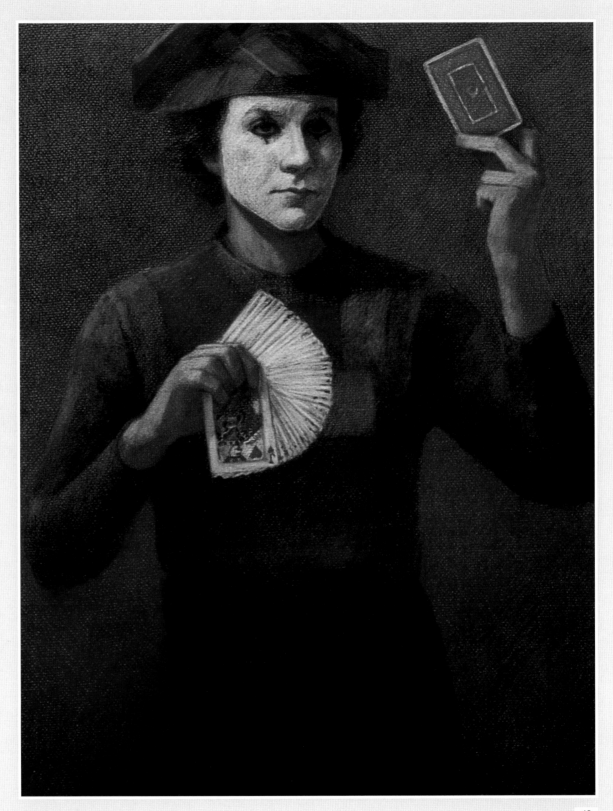

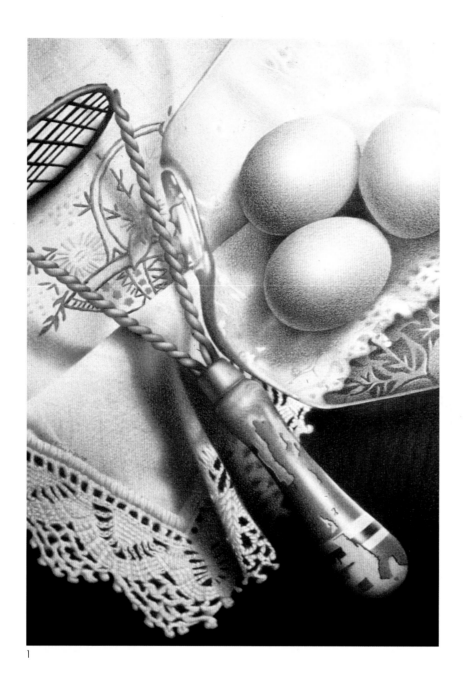

1

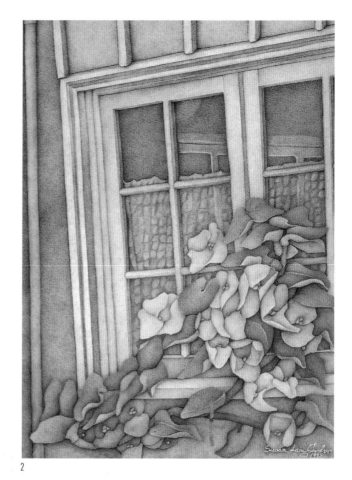

2

1

Jill Kline
Out of Time
33" x 26" (84 cm x 66 cm)
Bristol board hot press

2

Susan Lane Gardner
The Meeting Place
26" x 21" (66 cm x 53 cm)
Strathmore museum board

1

Barbara Newton
Rise and Shine
14" x 15" (36 cm x 38 cm)
Rising Stonehenge

2

Luanne D'Amico
Magnolia Grandiflora
28" x 34" (71 cm x 86 cm)
Bristol vellum finish

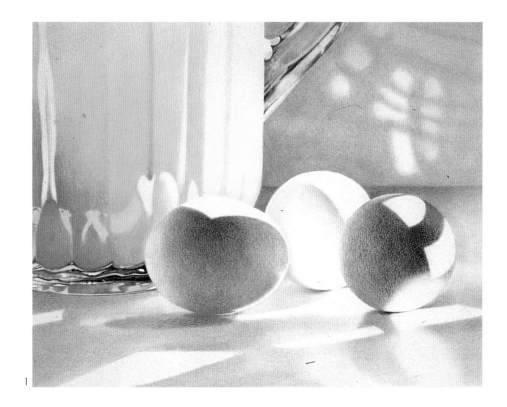

1

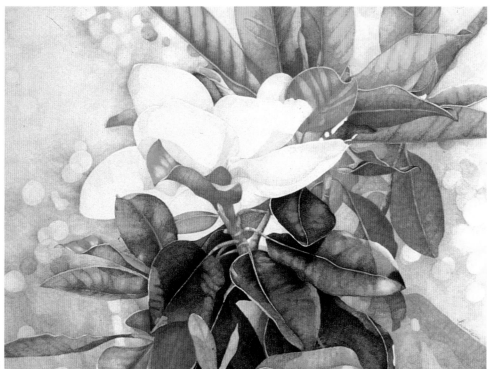

2

1
Sherry L. Smith
Still Life Study
27" x 35" (69 cm x 89 cm)
Strathmore 500 Series

2
Kathy Kerr
Gertrude Stein, Gertrude Stein
22" x 19" (56 cm x 48 cm)
Rising museum board

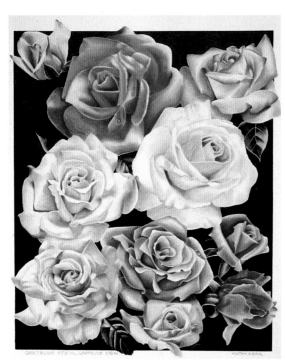

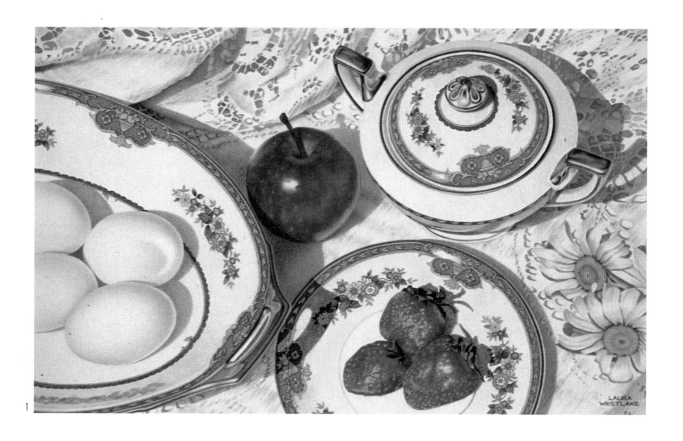

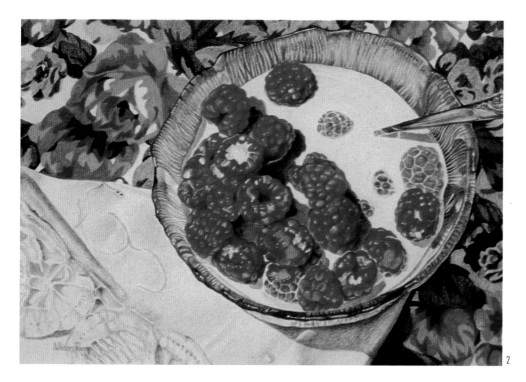

1

Laura Westlake
Remembrance
12" x 19" (30 cm x 48 cm)
Strathmore 500 Series, vellum

2

Allison Fagan
Raspberries on Chintz
15" x 18" (38 cm x 46 cm)
Arches Satine

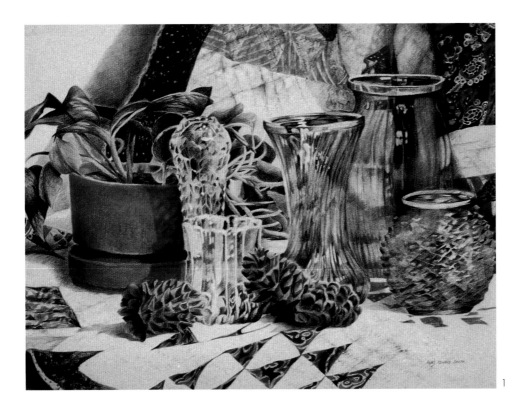

1

Anne Renard Smith
Waiting for Spring
28" x 36" (71 cm x 91 cm)
Arches hot press watercolor

2

Kay Moore Dewar
Reflections in Silver
18" x 20" (46 cm x 51 cm)
Strathmore bristol board

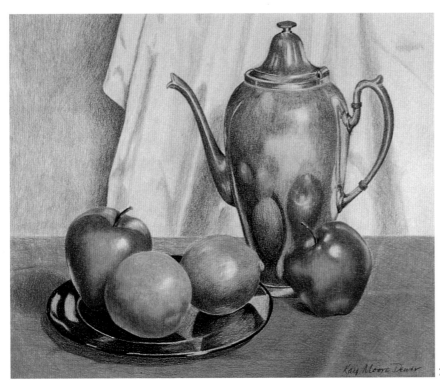

2

1

Joanne Smith Wood
Unexpected Light
17" x 22" (43 cm x 56 cm)
Bristol 3-ply vellum

2

Lynn A. Byrem
Light and Lace
19" x 25" (48 cm x 64 cm)
Bienfang Art-Vel 211

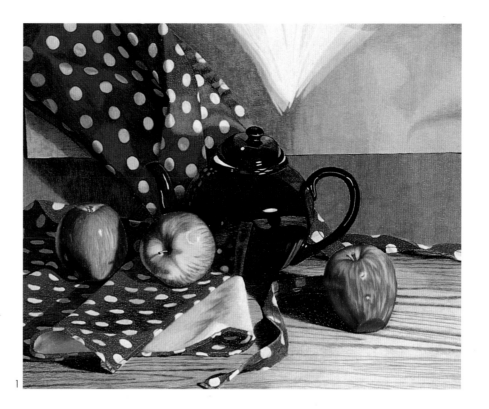

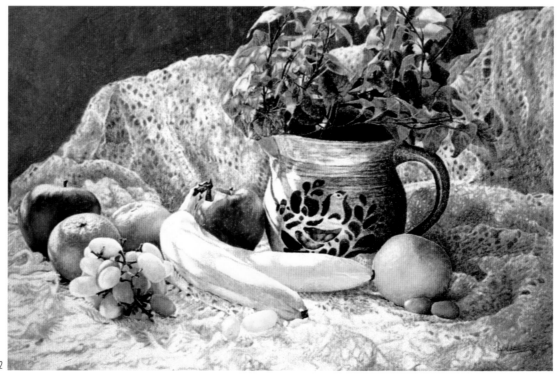

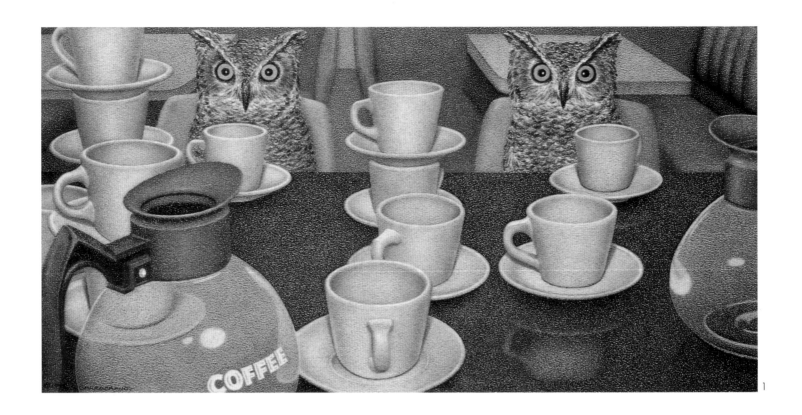

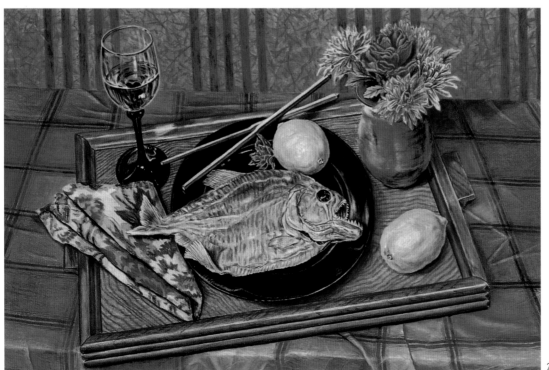

1

Bruce S. Garrabrandt
Why Owls are Nocturnal
10" x 15" (25 cm x 38 cm)
Bienfang bristol vellum

2

Melissa Taylor
Bone Appeteeth
25" x 30" (64 cm x 76 cm)
60 lb. paper

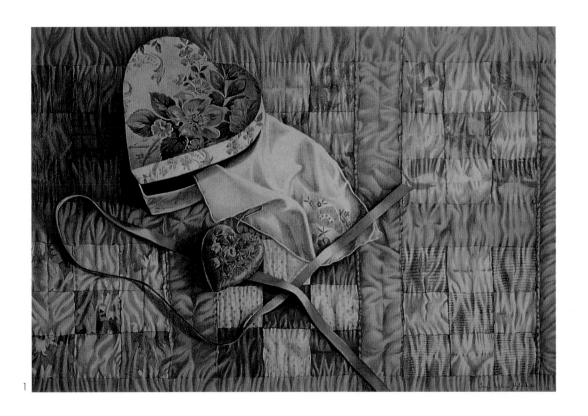

1
Susan Fulghum Hyback
Hearts & Flowers
25" x 34" (64 cm x 86 cm)
Arches 140 lb. hot press watercolor paper

2
Janie Gildow
Lace Reflections
15" x 18" (38 cm x 46 cm)
Crescent illustration board hot press 115

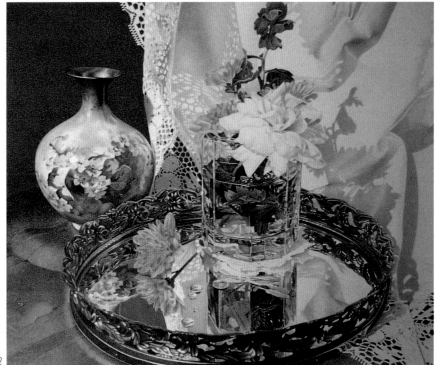

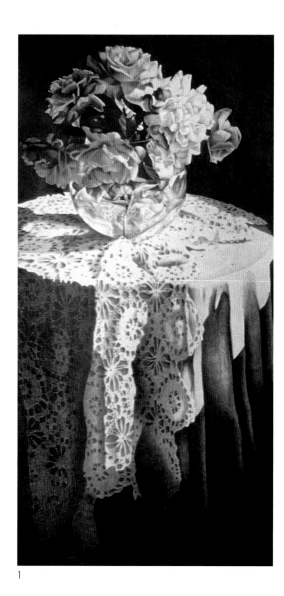

1

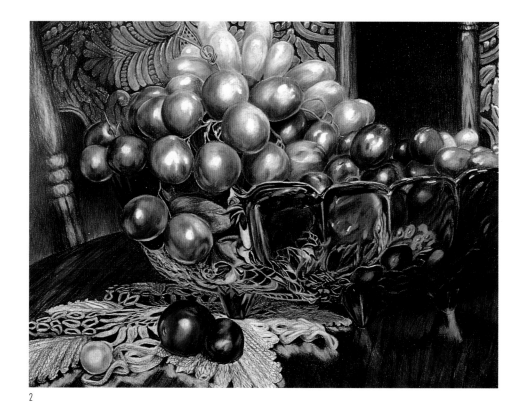

2

3

1

Joy Rose Walker
At Season's End
40" x 24" (102 cm x 61 cm)
Bristol board

2

Vera Susan Miller
Betty Weaver's Bowl
24" x 30" (61 cm x 76 cm)
Strathmore bristol board

3

Janie Gildow
Sparklers
15" x 12" (38 cm x 30 cm)
Rising Stonehenge

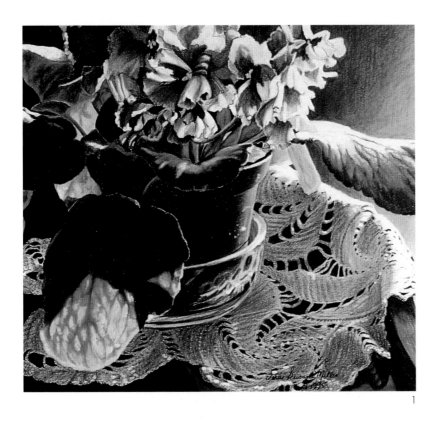

1

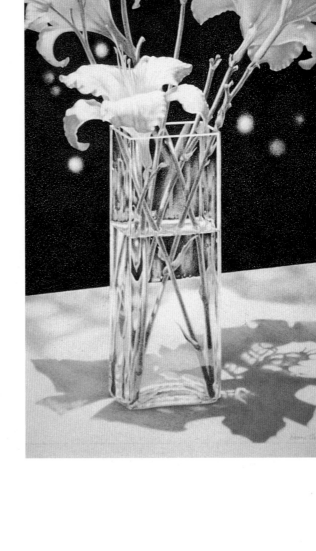

3

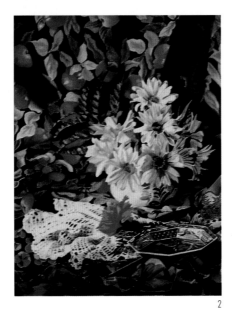

2

1

Vera Susan Miller
Afternoon Sun
20" x 20" (51 cm x 51 cm)
Museum board

2

Wendy Nelson Ackerman
October's Flowers
24" x 20" (61 cm x 51 cm)
Lenox 100% rag printing paper

3

Deane Ackerman
Signature Member
Daylilies
20" x 22" (51 cm x 55 cm)
Strathmore 80 lb. paper

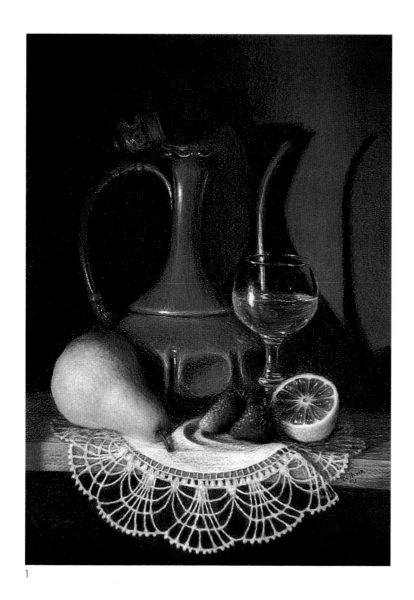

1

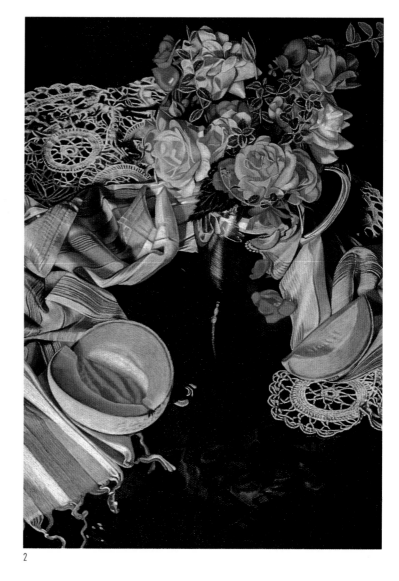

2

1

Martha DeHaven
Classic Pewter
23" x 19" (58 cm x 48 cm)
Canson Mi-Tientes

2

Ronni Wadler
Cantaloupe
24" x 16" (61 cm x 41 cm)
Canson Mi-Tientes

56

Diane Donicht Vestin
It's A Plum Party!
33" x 22" (84 cm x 56 cm)
Strathmore 500 Series, plate

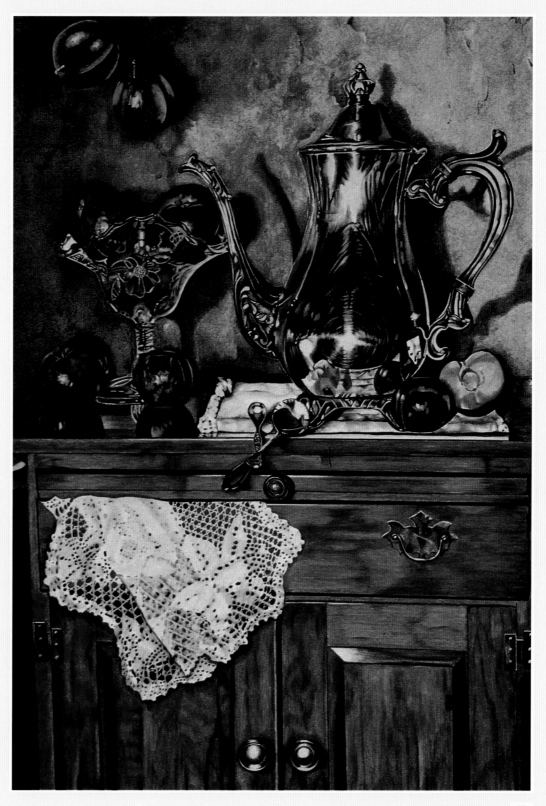

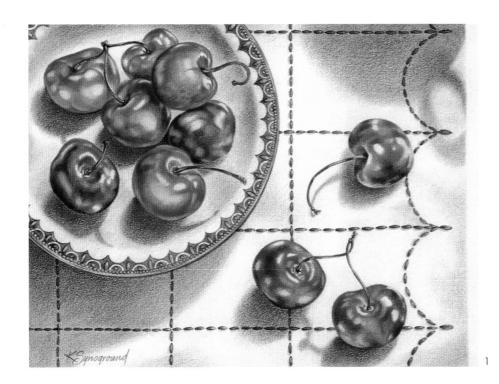

1
Kaye Synoground
Cherries Jubilee
16" x 18" (41 cm x 46 cm)
Museum board 100% rag

2
Gail T. Collier
Apple Vases
23" x 11" (58 cm x 28 cm)
Strathmore 3-ply bristol vellum

3
Kristy A. Kutch
Berry Bounty
24" x 22" (61 cm x 56 cm)
Rising museum board

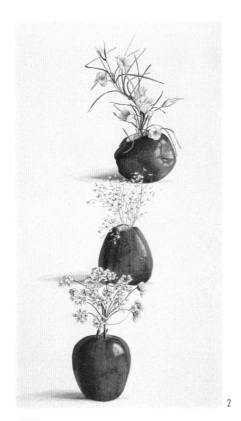

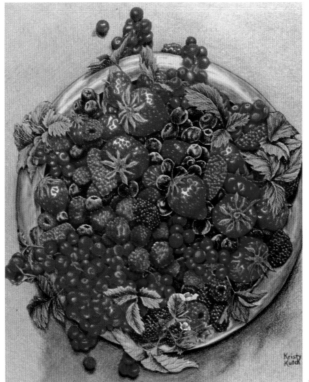

Barbara Newton
Sun Spots
13" x 12" (33 cm x 30 cm)
Rising Stonehenge

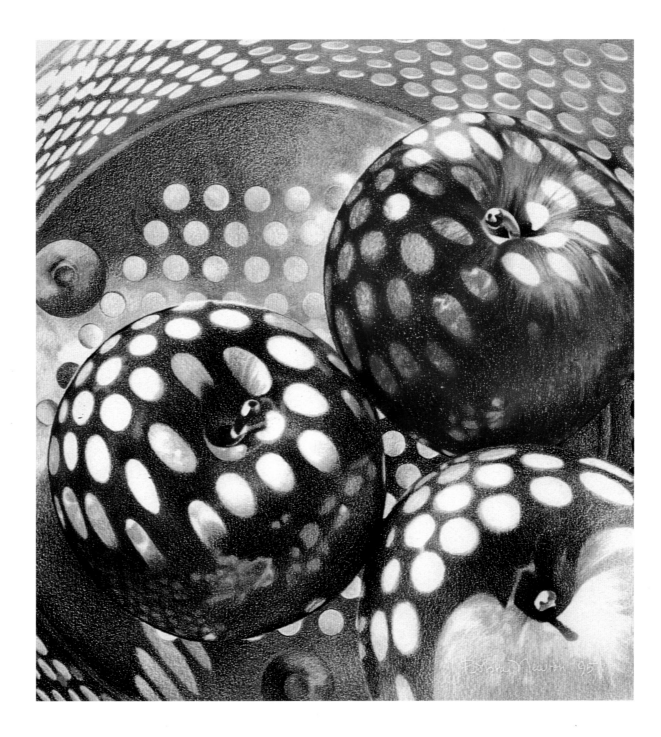

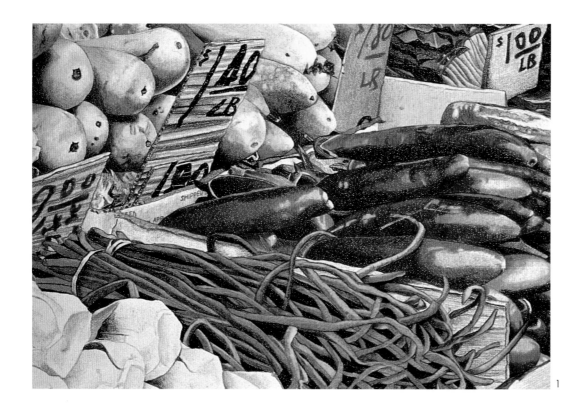

1

Cira Cosentino
Chinatown Vegetable Stand
14" x 16" (36 cm x 41 cm)
Canson paper

2

Betsey Blessing
Artichokes
26" x 21" (66 cm x 53 cm)
3-ply paper

3

Barbara E. Schwemmer
Cabbage Patchwork
27" x 36" (69 cm x 91 cm)
Bristol board

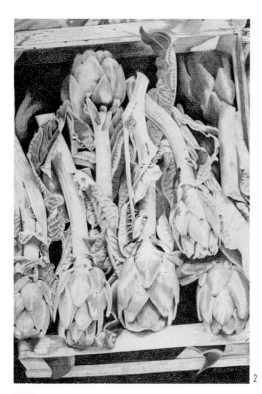

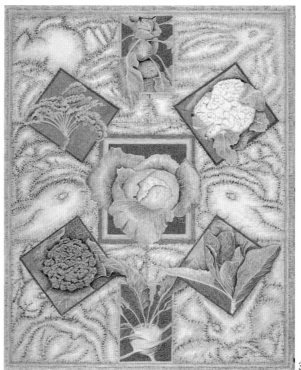

Joe Wong
Still Life with Crimson Pears & Yellow Peaches
16" x 20" (40 cm x 51 cm)
Rising museum board

2

Frances Caplan
Oranges
25" x 19" (64 cm x 48 cm)
Strathmore 500 Series plate

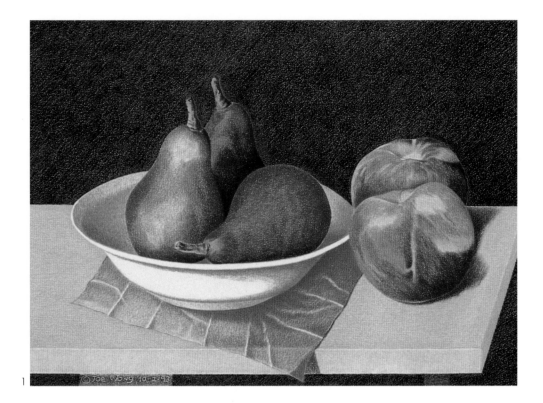

1

2

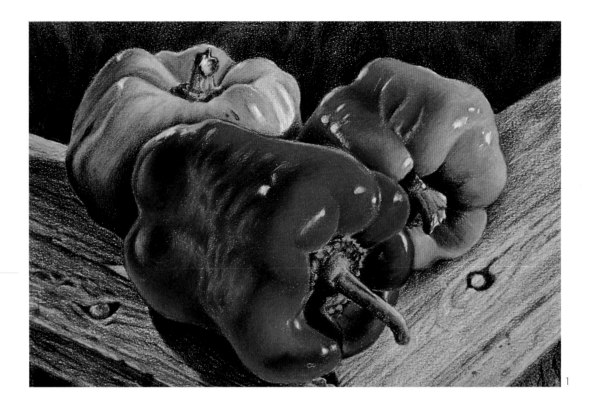

1

Ruth McCarty
A Fine Display
11" x 14" (28 cm x 36 cm)
Rising museum board

2

Sari Gaby
Life Boat
17" x 19" (43 cm x 48 cm)
Canson Mi-Tientes

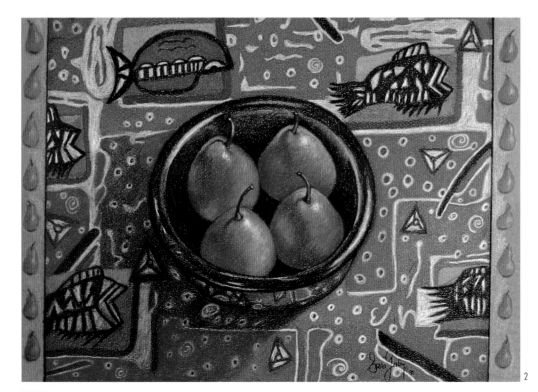

1

Shelly M. Stewart
Signature Member
Seven Shadows
11" x 14" (28 cm x 36 cm)
Bristol, plate finish

2

Shelly M. Stewart
Signature Member
Red Hot Mama in Repose
13" x 18" (33 cm x 46 cm)
Bristol, plate finish

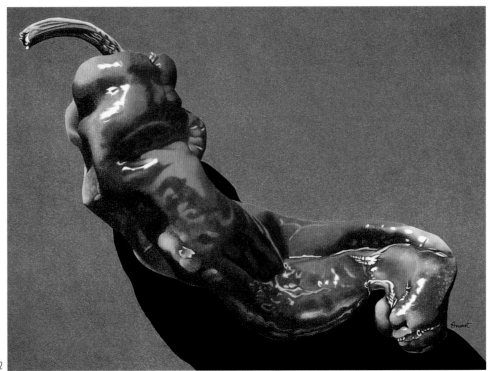

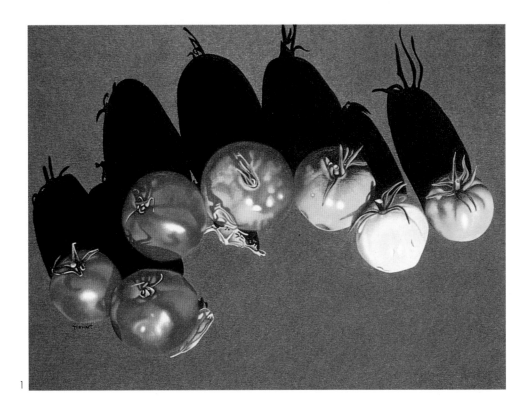

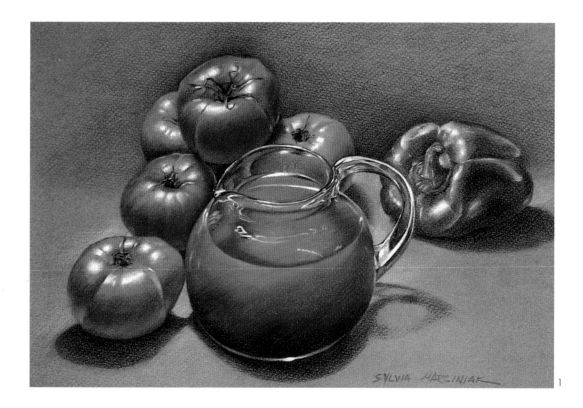

1

Sylvia Marciniak
Tomatoes and Green Pepper
18" x 21" (46 cm x 53 cm)
Toned illustration board

2

Martha DeHaven
Pomegranates and Pears
23" x 19" (58 cm x 48 cm)
Canson Mi-Tientes

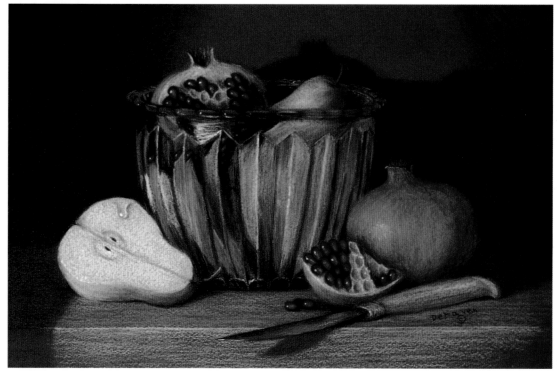

1

Joe Bascom
Signature Member
Cantaloupe No. 1
29" x 35" (74 cm x 89 cm)
Strathmore 2-ply medium

2

Edna Henry
Winter Pears
15" x 21" (38 cm x 53 cm)
Rising Stonehenge

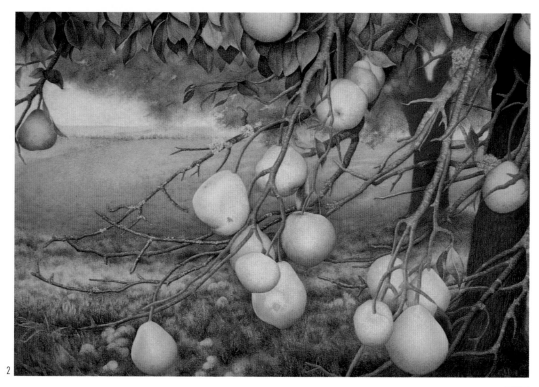

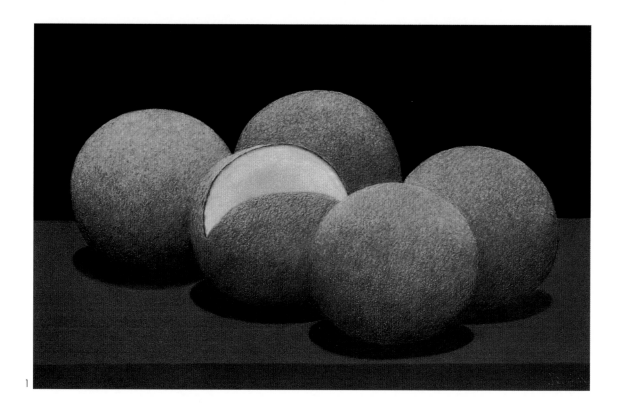

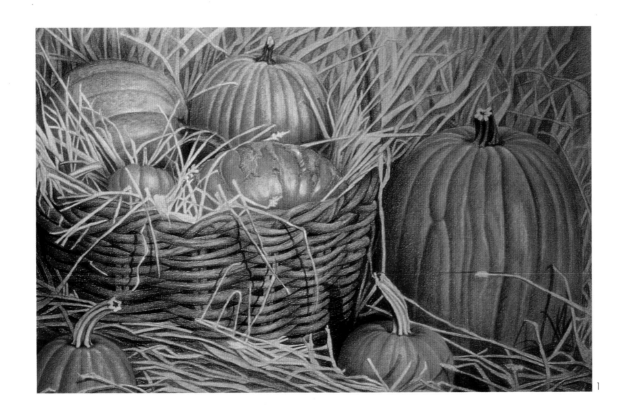

1

Cathy Heller
Grapevine and Gourds
20" x 25" (51 cm x 64 cm)
Strathmore 3-ply

2

Michele Johnsen
Squash
18" x 20" (46 cm x 51 cm)
Strathmore 500 Series

3

Ruth McCarty
Apples II
20" x 16" (51 cm x 41 cm)
Rising museum board

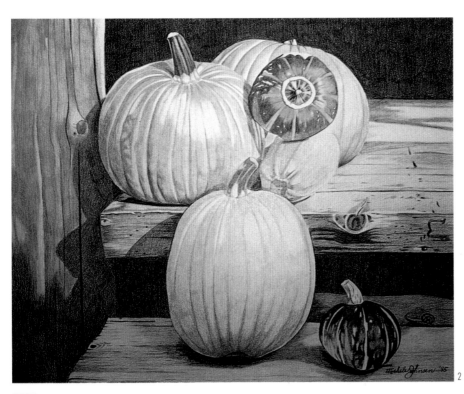

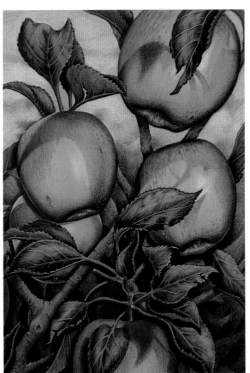

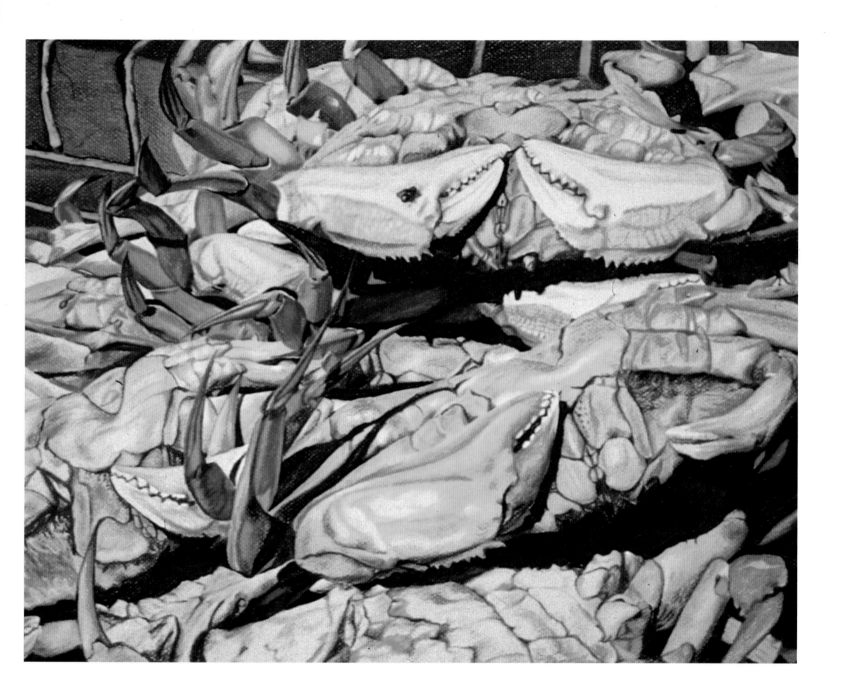

Nancy Garcia
Yes, We Serve Crabs
22" x 25" (56 cm x 64 cm)
Canson Mi-Tientes

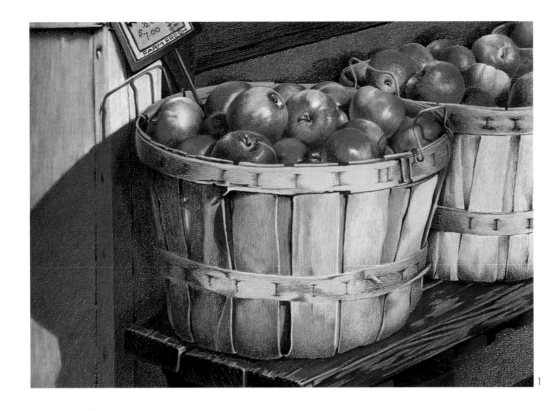

1

Judith Forscey-Milledge
Ellington Apples
26" x 32" (66 cm x 81 cm)
Strathmore Artagain

2

Norman Holmberg
Autumn Berries
32" x 40" (81 cm x 102 cm)
Arches hot press 140 lb.

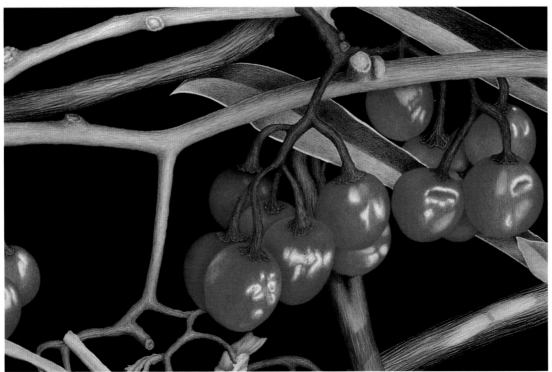

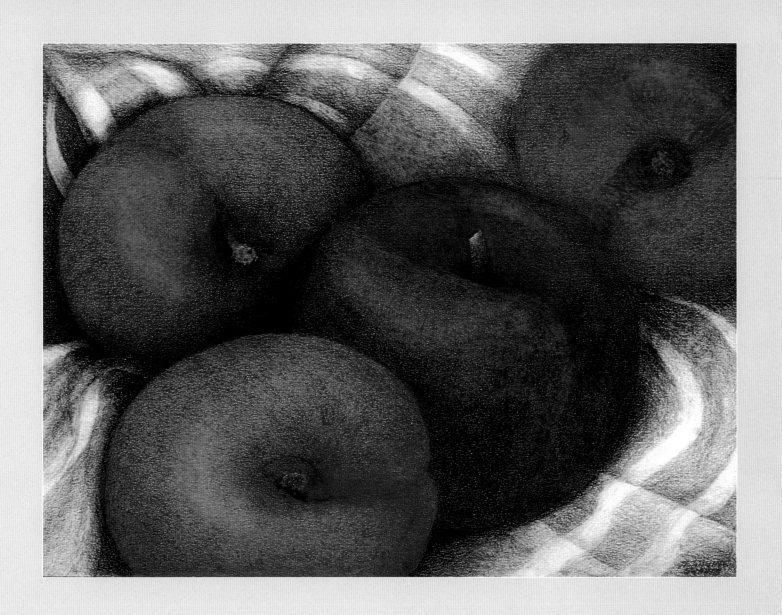

Jeannine Swarts
Plums & Stripes
20" x 24" (51 cm x 61 cm)
Rising museum board

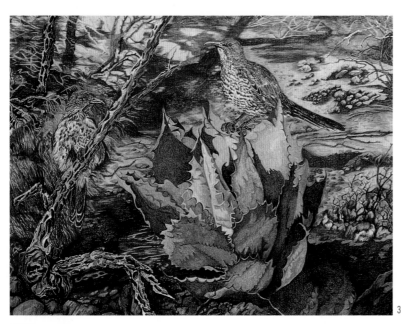

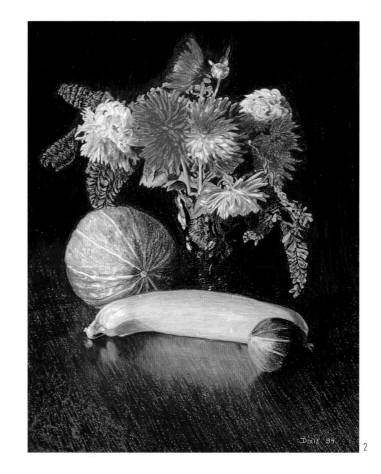

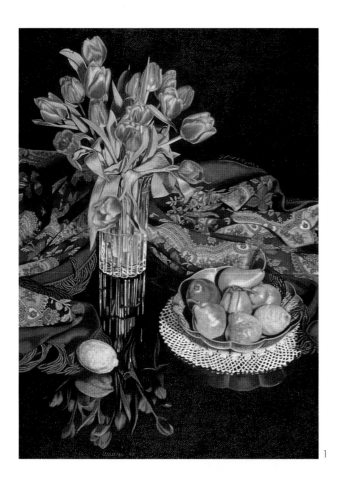

1
Ronni Wadler
Pears and Lemons
27" x 20" (69 cm x 51 cm)
Canson Mi-Tientes

2
Dixie Smith
Dahlias and Squashes
28" x 21" (71 cm x 53 cm)
Rising Stonehenge

3
Donna Gaylord
Signature Member
Curved Bill Thrashers
29" x 35" (74 cm x 89 cm)
Bristol board vellum

Katharine Flynn
Primal Garden
22" x 27" (56 cm x 69 cm)
Strathmore 500 Series 4-ply

Terry Sciko
Signature Member
The Fourth of October
26" x 36" (66 cm x 91 cm)
Crescent mat board

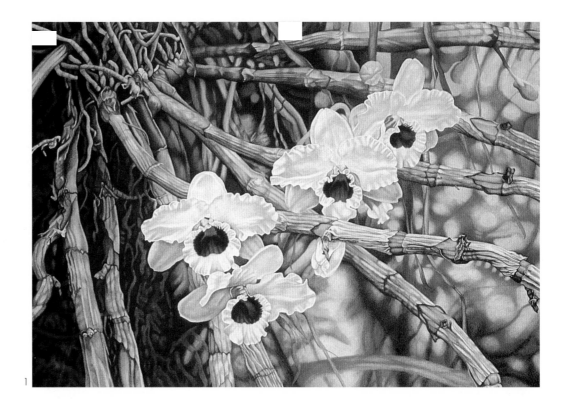

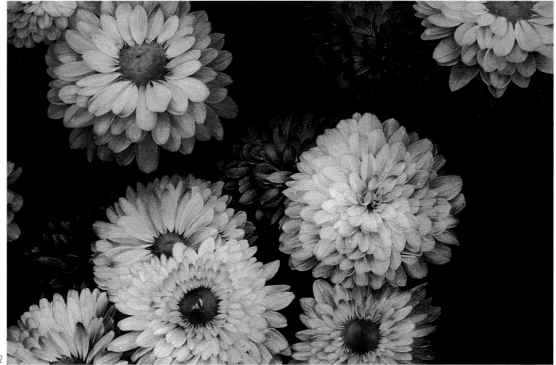

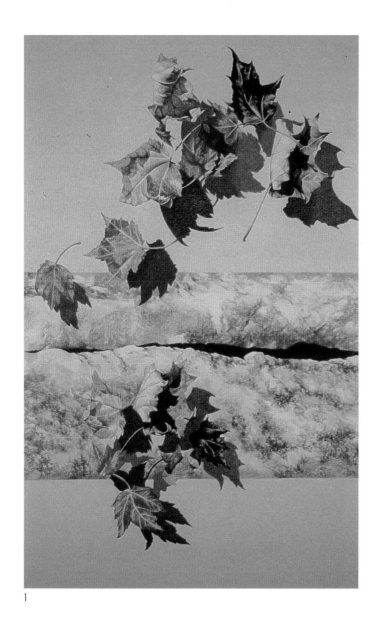

1

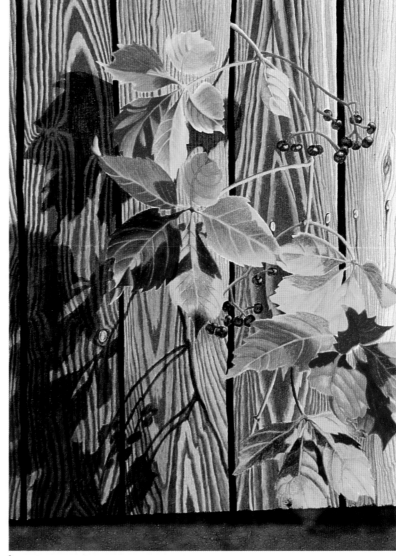

2

1

Jeanne Tennent
Beyond My Wall
30" x 20" (76 cm x 51 cm)
Crescent illustration board

2

Joanne Smith Wood
Fence Art
18" x 14" (46 cm x 36 cm)
Bristol 3-ply vellum

72

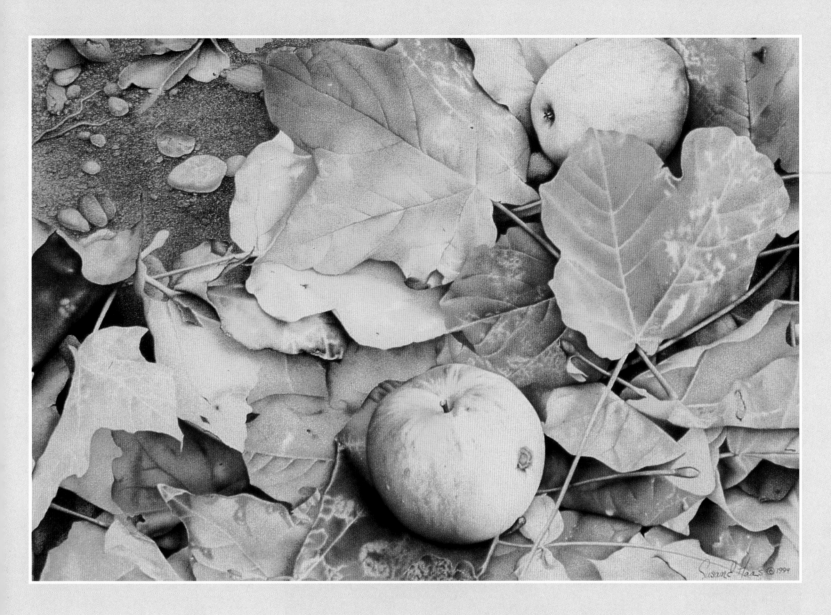

Susan E. Haas
Autumn Song
18" x 21" (46 cm x 53 cm)
Bristol board

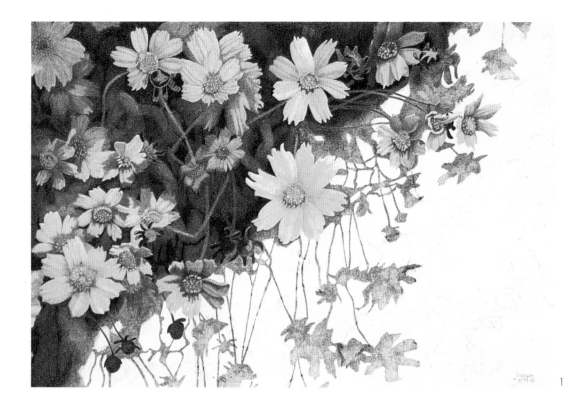

1

Janet S. Brown
Coreoptical
17" x 23" (43 cm x 58 cm)
Rising museum board

2

Alma L. Parks
Crocus
15" x 19" (38 cm x 48 cm)
Illustration board

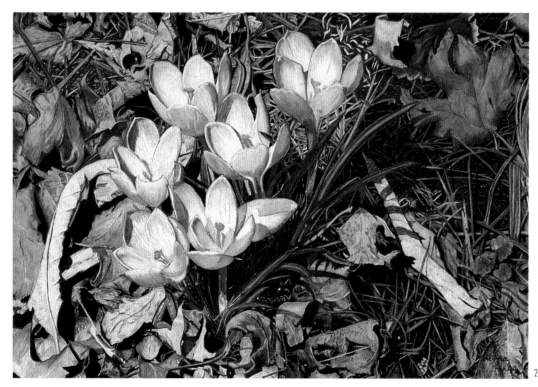

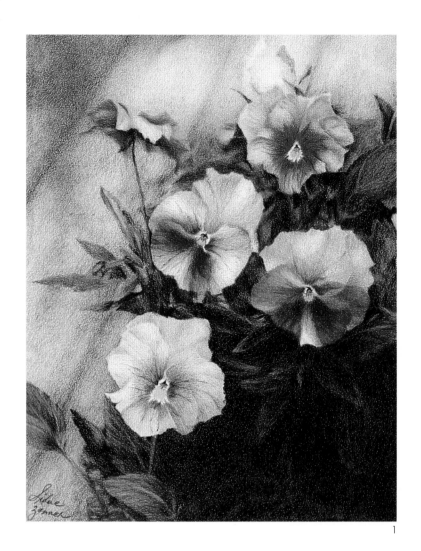

1

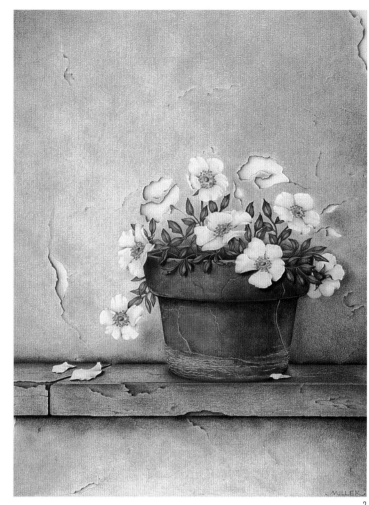

2

1
Sidne Zenner
Pansy Delights
18" x 16" (46 cm x 41 cm)
Rising 4-ply bristol

2
Linda M. Miller
At Second Glance
26" x 21" (66 cm x 53 cm)
Bristol board, smooth

75

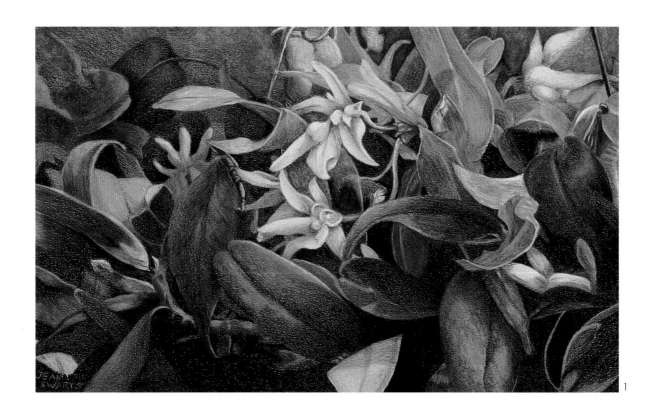

1
Jeannine Swarts
Tropical Flowers I
14" x 18" (36 cm x 46 cm)
Crescent mat board

2
Mary Pohlmann
White Frangipani
22" x 30" (56 cm x 76 cm)
Arches hot press watercolor paper

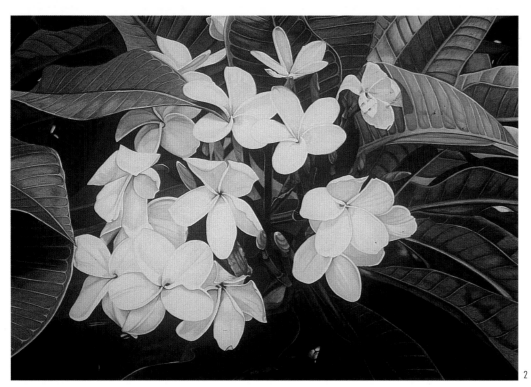

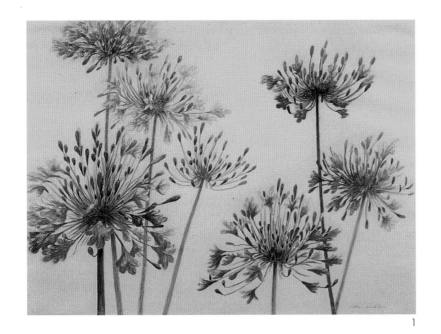

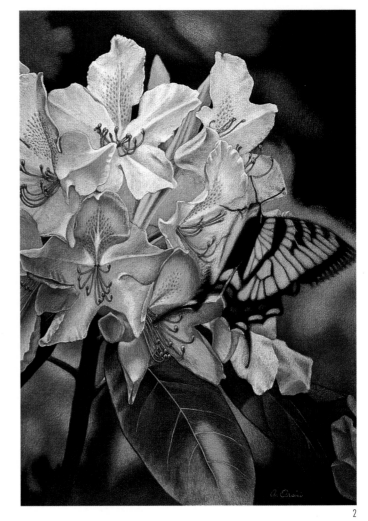

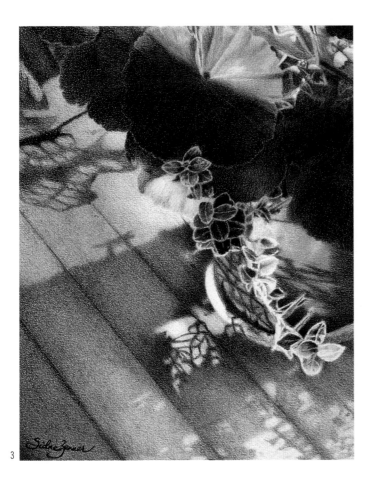

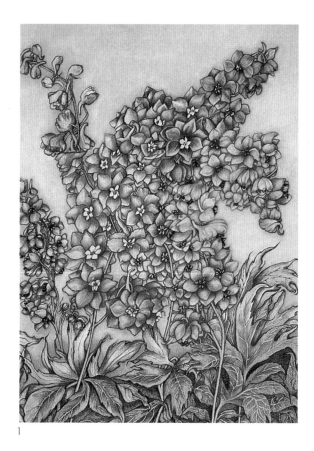

1

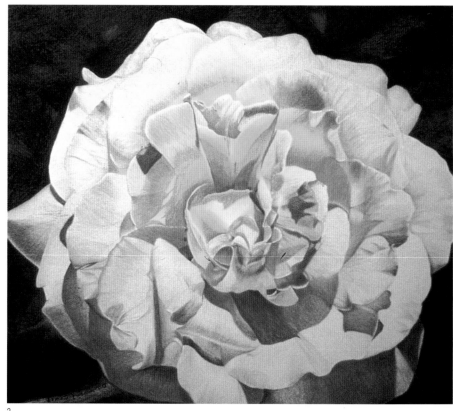

2

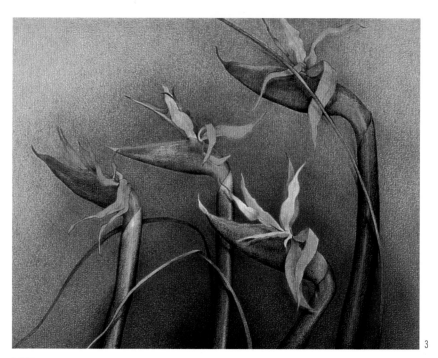

3

1

Martha Cardot-Greiner
Purple Delphiniums-After the Storm
17" x 28" (43 cm x 71 cm)
Strathmore bristol board

2

D. Thornburg James
Rose Explosion
24" x 26" (61 cm x 66 cm)
Arches hot press

3

Kathryn Conwell
Strelitizia Reginae
21" x 24" (53 cm x 61 cm)
Museum board

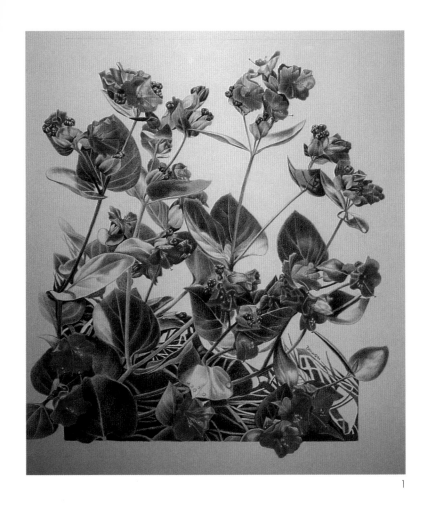

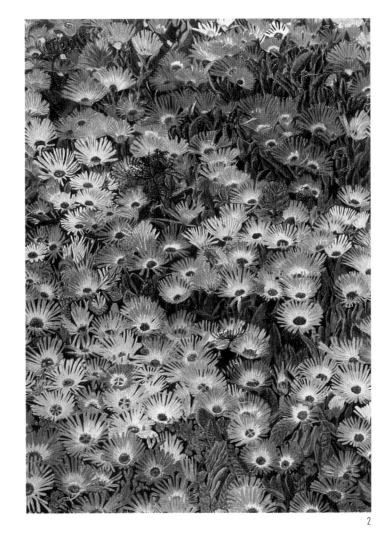

1

2

1
Rebecca Brown-Thompson
Mirabilis Macfarlane
20" x 18" (51 cm x 46 cm)
Scanner board

2
Mary G. Hobbs
Oregon August
32" x 24" (81 cm x 61 cm)
Onionskin silk paper

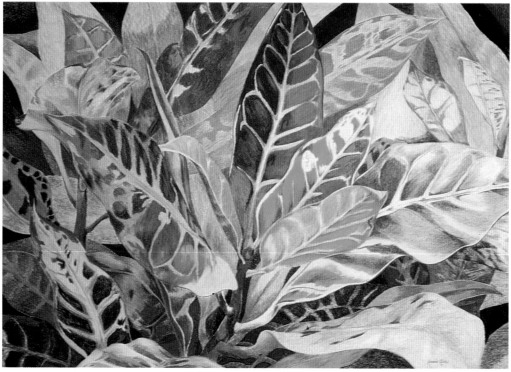

1

Lonnie Rich
Leaves of Wax II
32" x 40" (81 cm x 102 cm)
100% rag paper

2

Norah C. Walker
Greenhouse Stowaways
20" x 26" (50cm x 66cm)
Strathmore 400 Series

1

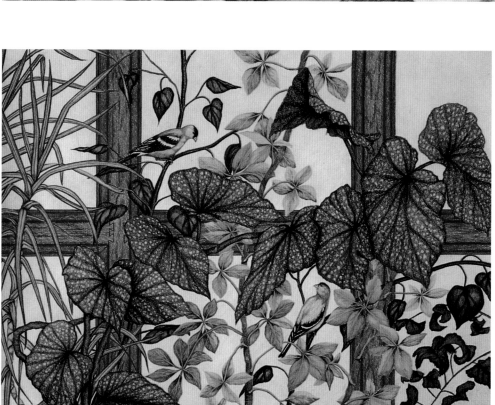

2

Donna Gaylord
Signature Member
Saguaro Splendor
37" x 27" (94cm x 69cm)
Strathmore museum board

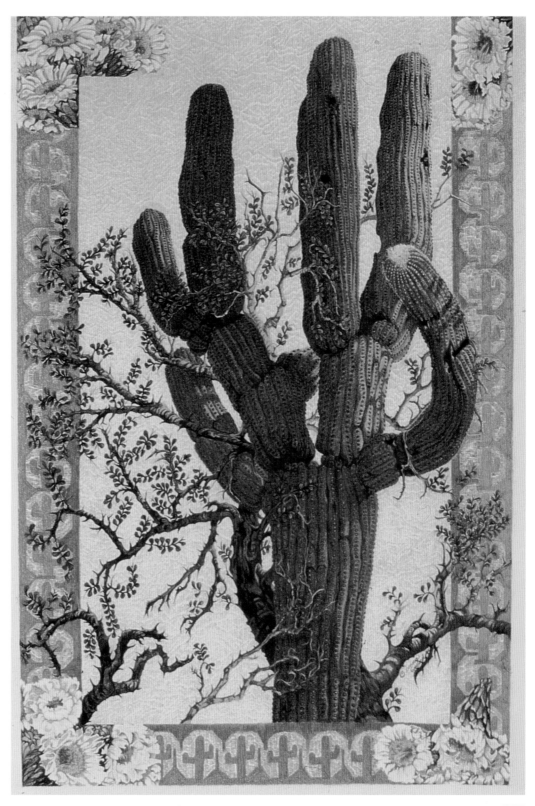

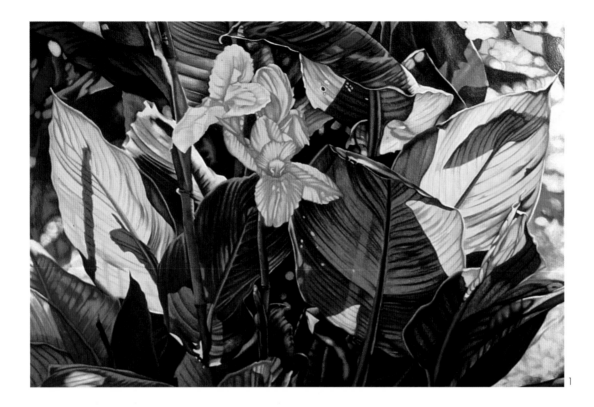

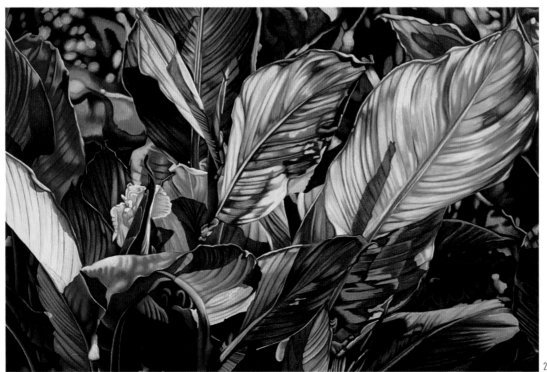

1
Tim O'Neal
Rand Cannas 2
21" x 30" (53 cm x 76 cm)
White Stonehenge

2
Tim O'Neal
Rand Canna 1
21" x 30" (53 cm x 76 cm)
White Stonehenge

Richard Drayton
Love Bird of Paradise
34" x 25" (86 cm x 64 cm)
2-Ply museum board

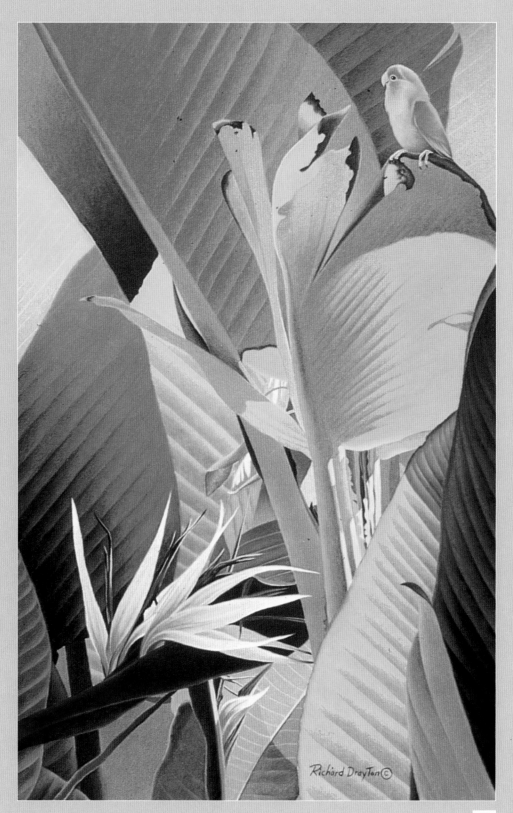

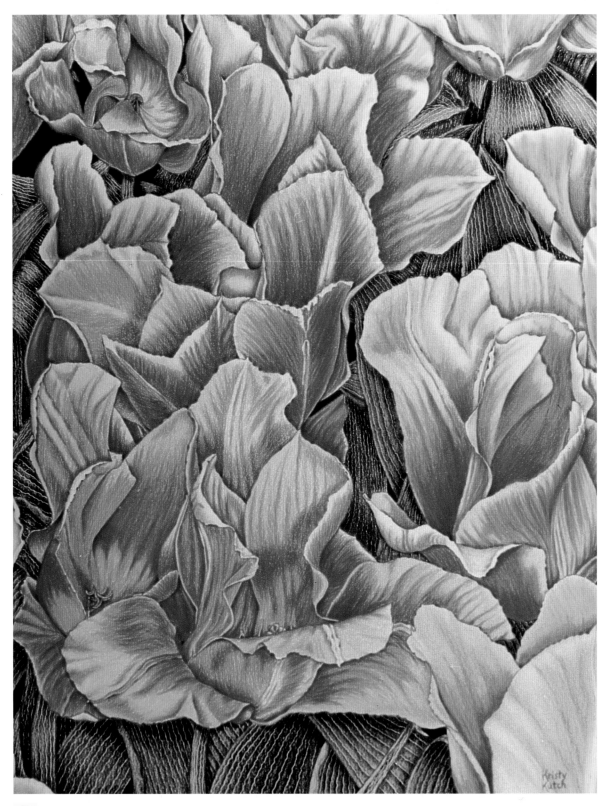

Kristy A. Kutch
Tulip Riot
26" x 20" (66 cm x 51 cm)
Rising museum board

1

Kathy Kerr
Apricot Begonias
6" x 8" (15 cm x 20 cm)
Strathmore 3-ply acid-free

2

Mary Pohlmann
Orchids II
20" x 30" (51 cm x 76 cm)
Arches hot press watercolor paper

2

Mary G. Hobbs
Before the Stars Turn To Ebony
30" x 32" (76 cm x 81 cm)
Rising museum board 1607

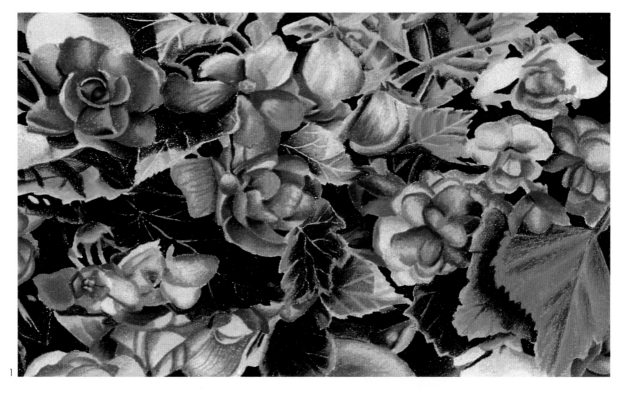

1

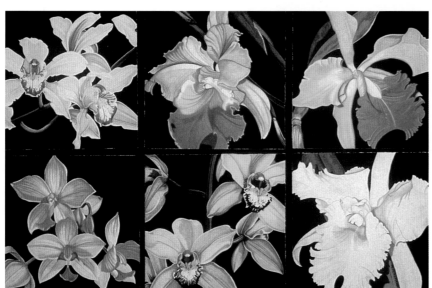

2

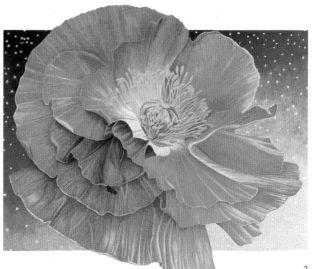

3

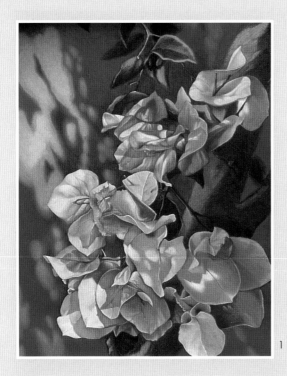

1

Laura Ospanik
Shades of Bougainvillea
34" x 28" (86 cm x 71 cm)
Canson Mi-Tientes

2

Susan L. Brooks
Calla Lilies
23" x 27" (58 cm x 69 cm)
Rising museum board

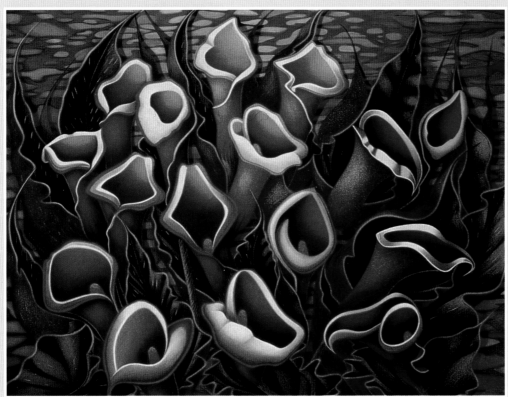

2

1

Darryl J. Alello
Palm Saga
11" x 15" (28 cm x 38 cm)
Medium texture paper

2

Dyanne Locati
Signature Member
A Forest of Palms
32" x 40" (81 cm x 102 cm)
Arches hot press

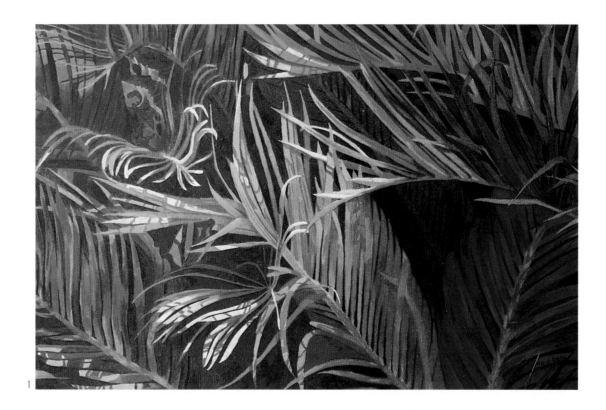

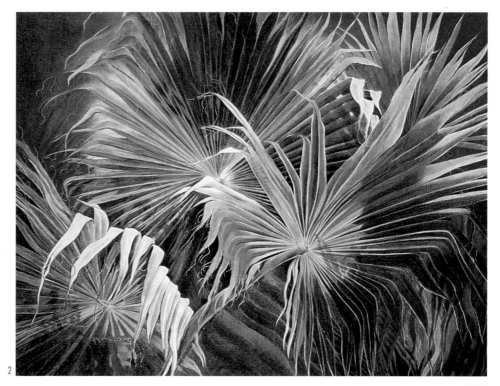

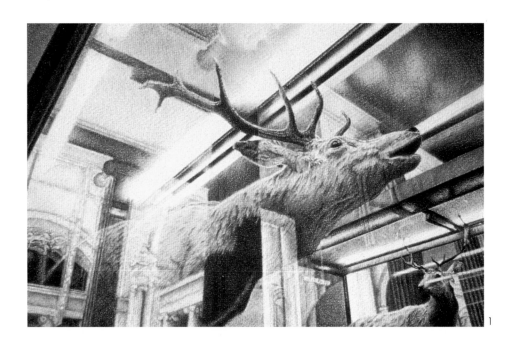

1

Gilbert Rocha
Reflections of a Red Deer
9" x 13" (23 cm x 33 cm)
Fabriano cold press 140 lb. watercolor

2

Tanya Harvey
Daydreaming-Leopard
26" x 16" (66 cm x 41 cm)
Rising Stonehenge

3

Stefan Geissbuhler
Spirit of the Rain Forest
26" x 20" (66 cm x 51 cm)
Canson Mi-Tientes

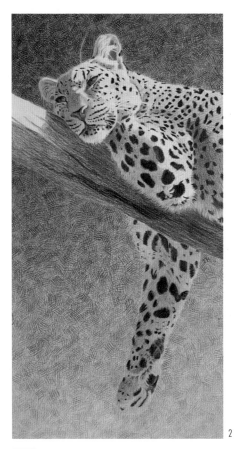

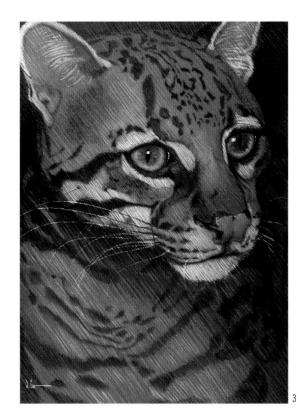

1

Carolyn Rochelle
Cat Nap
8" x 11" (20 cm x 28 cm)
Rising museum board

2

Caroline Kaiser
Alert Touraco
17" x 24" (43 cm x 61 cm)
Peterboro illustration board 79

3

Judy A. Freidel
Imagine—Zebras in the Pumpkin Patch
27" x 24" (69 cm x 61 cm)
Canson Mi-Tientes

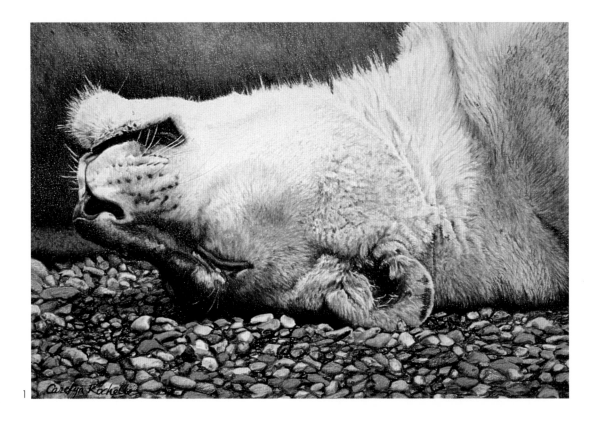

2

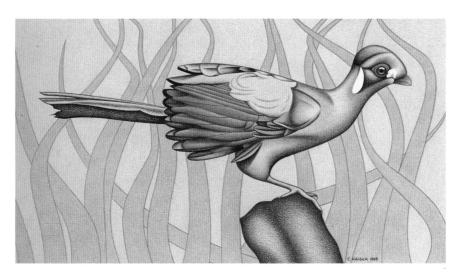

1

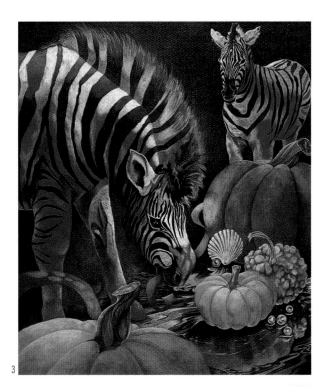

3

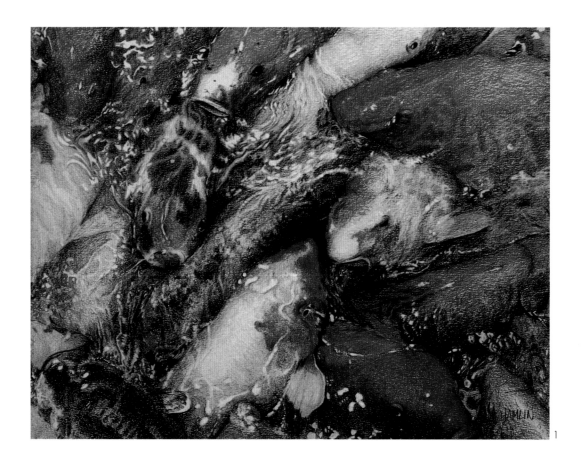

1

Linda Jo Hamlin
Water Dance
24" x 28" (61 cm x 71 cm)
Strathmore 3-ply bristol

2

Allison S. Beck
Sea Garden
20" x 24" (51 cm x 61 cm)
4-ply museum board

3

Beth Ward-Donahue
Coaster Brook Trout
10" x 12" (25 cm x 30 cm)
Vicksburg Archiva cover stock

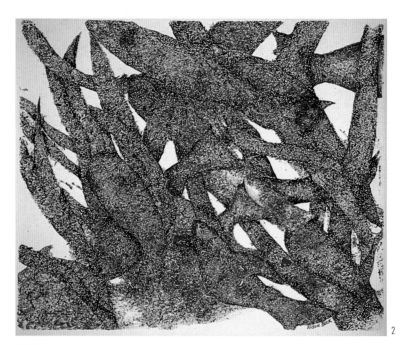

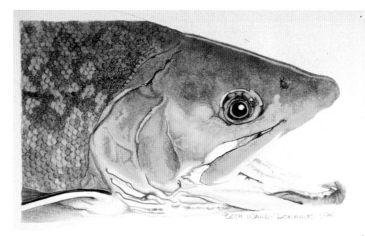

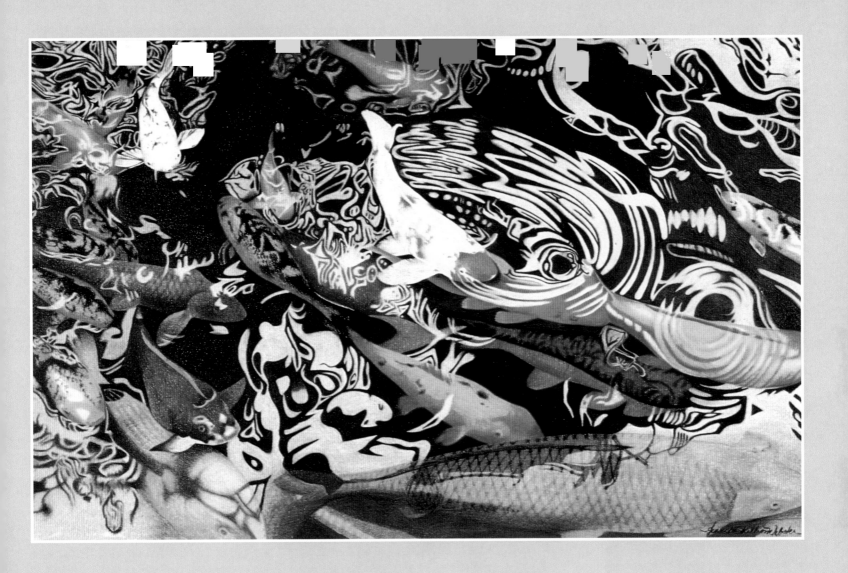

Jennifer Phillips Webster
Thirty-Some Odd Fish
19" x 27" (48 cm x 68 cm)
Bristol board

1

Denise Jigarjian
An Honest Days Work
16" x 21" (41 cm x 53 cm)
Strathmore Artagain

2

Beverly Heath-Rawlings
Lamiega
18 ¾" x 13"

3

Renee Durkee Atkinson
Clan of the Eagle
36" x 30" (91 cm x 76 cm)
Canson Mi-Tientes

2

3

1

Doreen Lindstedt
Old Lab #2
20" x 26" (51 cm x 66 cm)
Lana Aquarelle watercolor paper

2

Gale Simonson
Kauai Cat & Island Birds
20" x 16" (51 cm x 41 cm)
4-Ply museum board

3

Claudia M. Myers
Cat in the Grass
21" x 17" (53 cm x 43 cm)
Crescent mat board

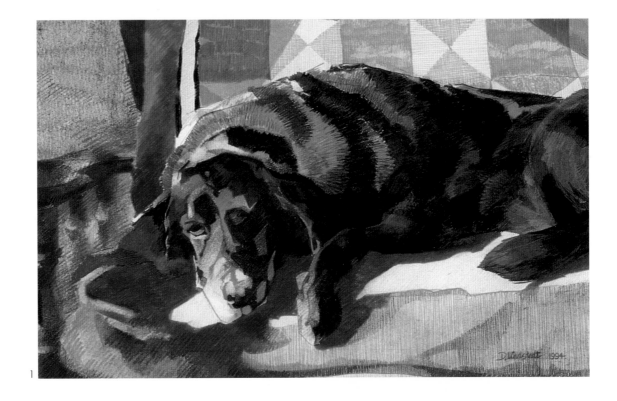

1

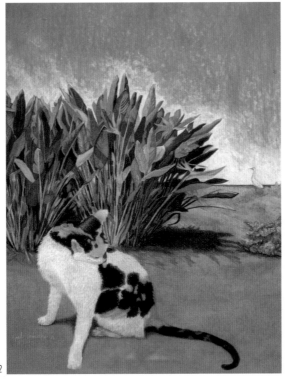

2

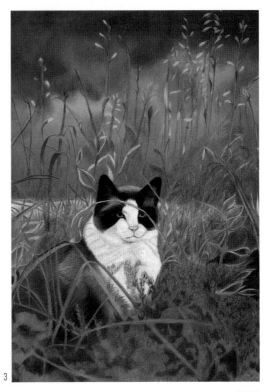

3

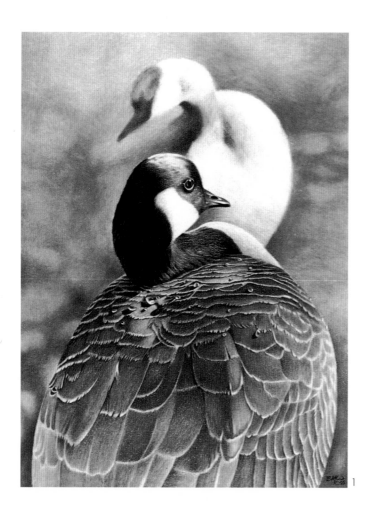

1

Bruce Martin Westberg
The Canadian
19" x 15" (48 cm x 38 cm)
Cold press illustration board

2

Julie Coverly
Annie, Fannie, Granny and Aunt Pearl
22" x 28" (56 cm x 71 cm)
Strathmore paper, black

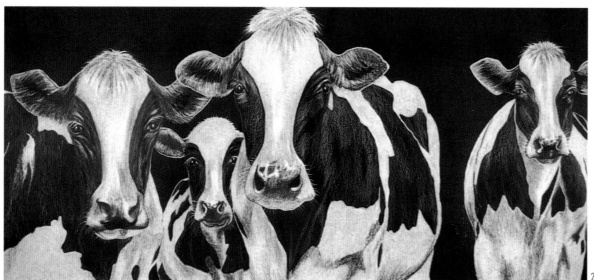

Susan Y. West
Daydreaming
30" x 26" (76 cm x 66 cm)
Rives BFK

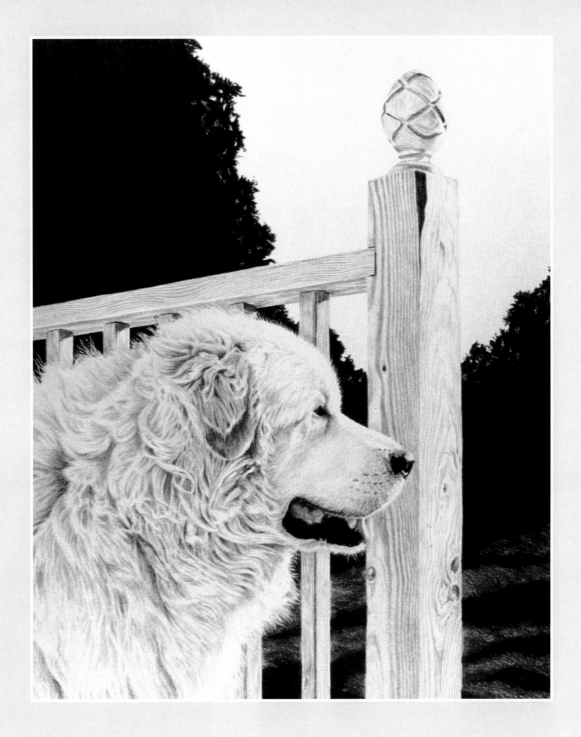

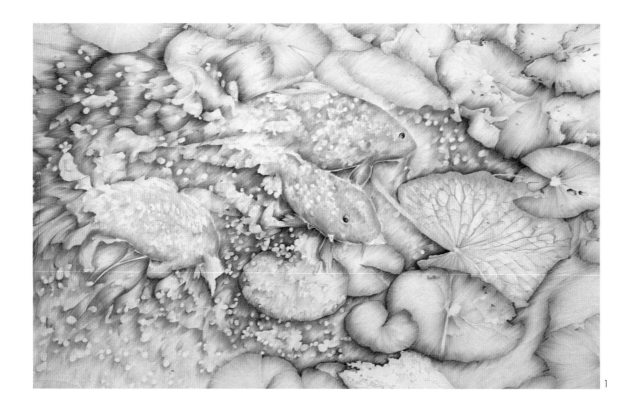

1
Susan Morse
Summer Pond
24" x 31" (61 cm x 79 cm)
Arches hot press board

2
Kristin Warner-Ahlf
What's for Dinner ?
17" x 15" (43 cm x 38 cm)
Strathmore 500 Series

3
Chere Fleischer
Flying Free
16" x 20" (41 cm x 51 cm)
Canson plate finish

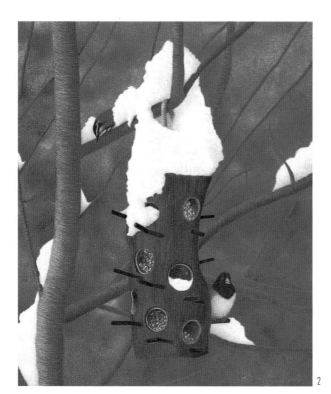

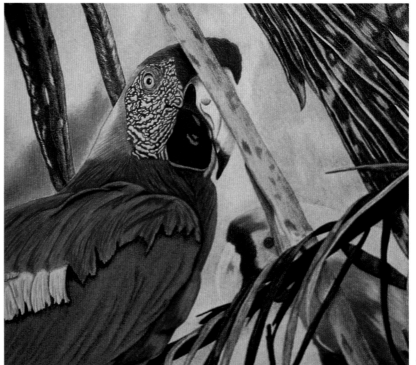

Edward Pikar
Macaw Parrot
16" x 20" (41 cm x 51 cm)
Bienfang smooth finish

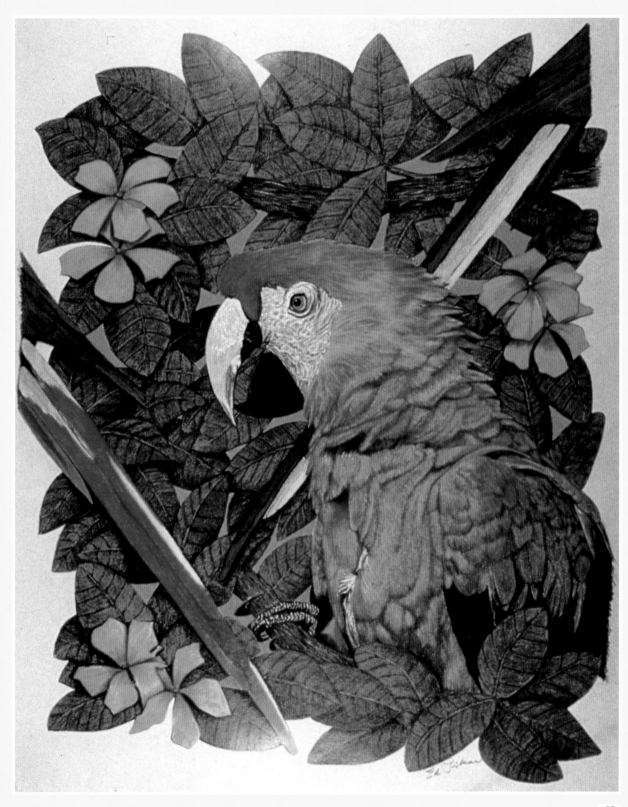

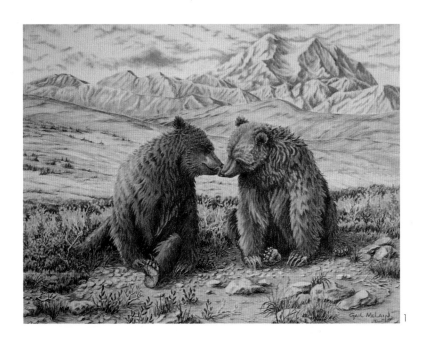

1
Gail McLain
A Lick and a Promise
15" x 18" (38 cm x 46 cm)
Coquille board

2
Joe Hyatt
The Last Temptation of Augie
17" x 24" (43 cm x 61 cm)
Rising museum board

3
Barbara E. Schwemmer
Parrots
19" x 23" (48 cm x 58 cm)
Strathmore museum board

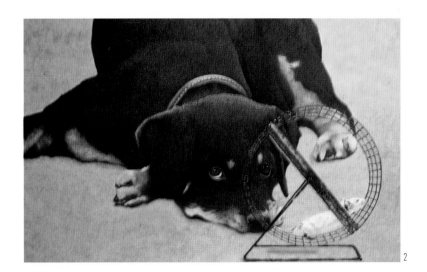

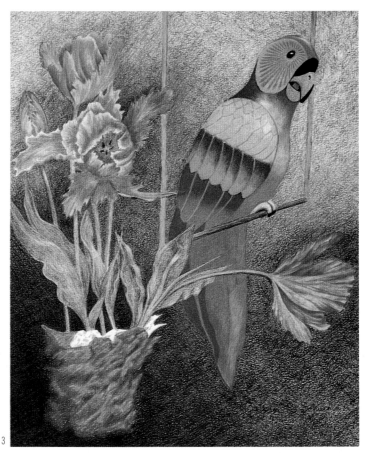

1

Gilbert Rocha
Classical Images II
14" x 24" (36 cm x 61 cm)
Fabriano cold press 140 lb. watercolor

2

Viktoria La Paz
Alone Wolf, Wanting
19" x 16" (48 cm x 41 cm)
Crescent illustration board 215

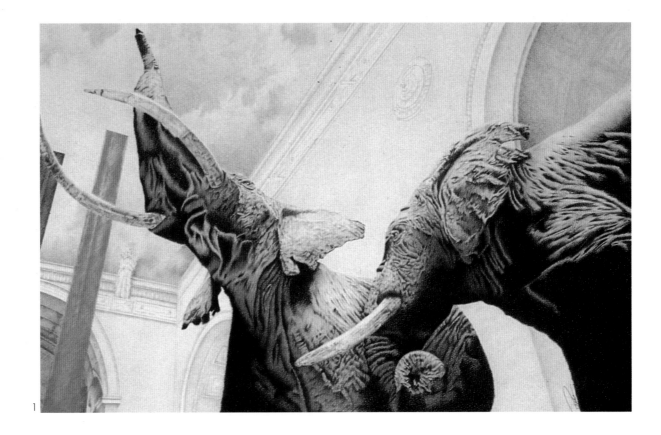

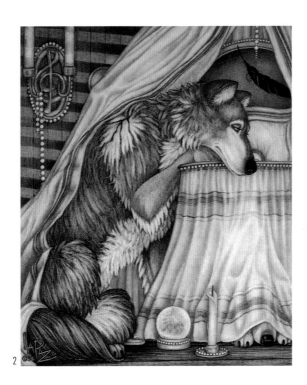

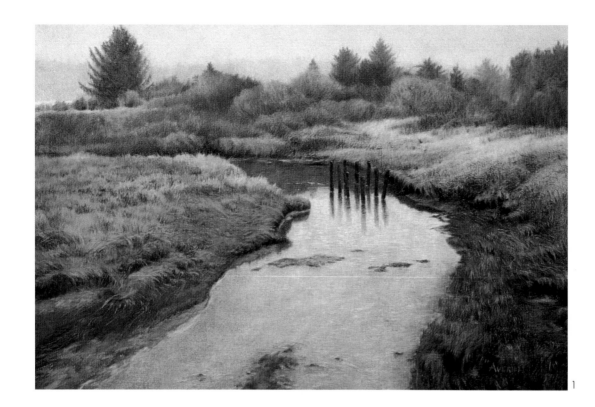

1

Pat Averill
Signature Member
Reverie
13" x 14" (33 cm x 36 cm)
Strathmore 4-ply museum board

2

Pat Averill
Signature Member
Smelt Sands
25" x 31" (64 cm x 79 cm)
Strathmore 300 watercolor paper

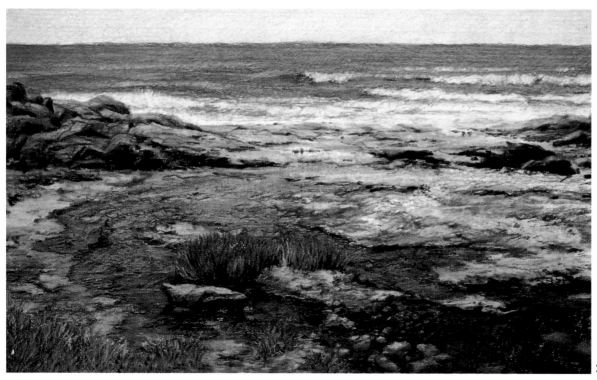

1

Iris Stripling
Safe Harbor
16" x 20" (41 cm x 51 cm)
Strathmore bristol

2

Mike Pease
Farmyard
32" x 31" (81 cm x 79 cm)
2-Ply white museum board

3

Carlynne Hershberger
Skyward
24" x 20" (61 cm x 51 cm)
Canson Mi-Tientes pastel paper

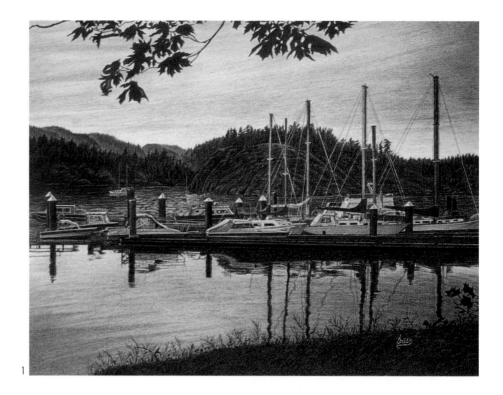

1

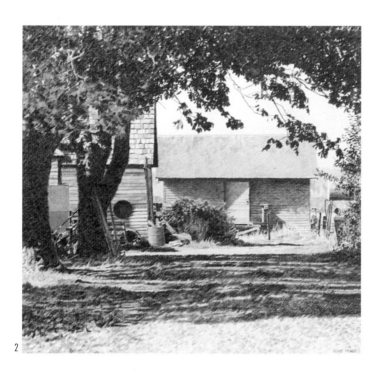

2

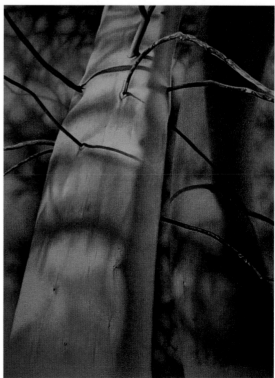

3

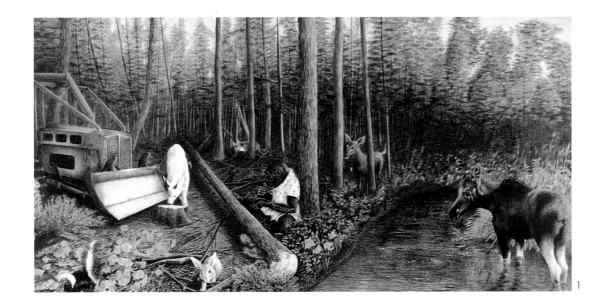

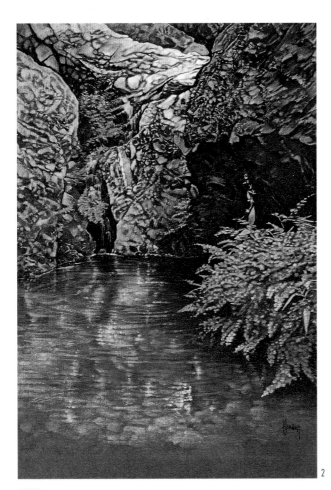

2

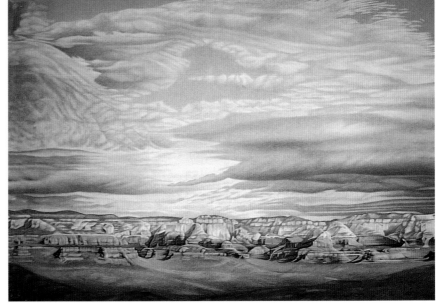

3

102

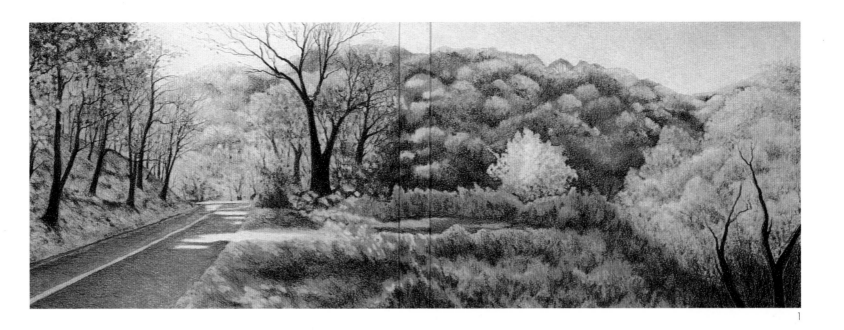

1

Marguerite Dailey Matz
Fall Spectrum
19" x 36" (48 cm x 41 cm)
Berol Prismacolor paper

2

Marguerite Dailey Matz
Wendy's Birthday
16" x 20" (41 cm x 51 cm)
Rising Stonehenge

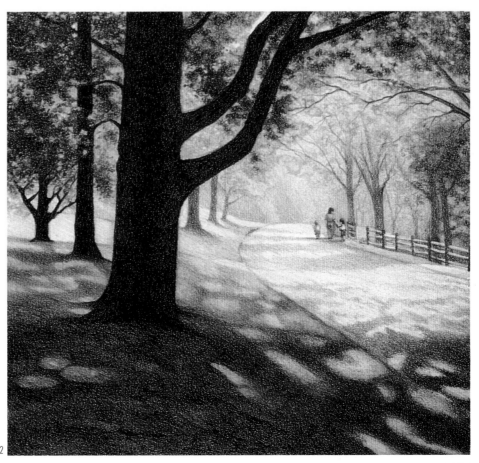

2

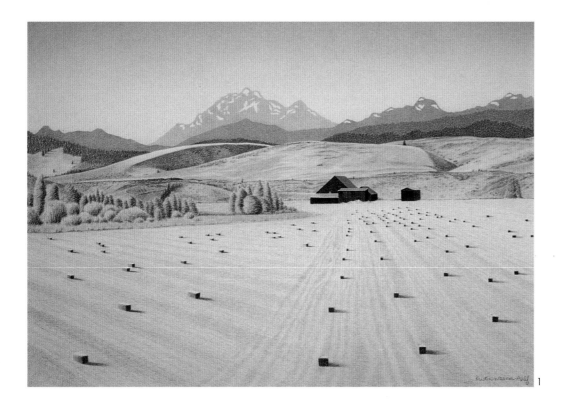

1

Kristin Warner-Ahlf
Make Hay While the Sun Shines
20" x 24" (50 cm x 60 cm)
Rising Stonehenge

2

Don Pearson
Bierstadt Lake
9" x 11" (23 cm x 28 cm)
Mat board

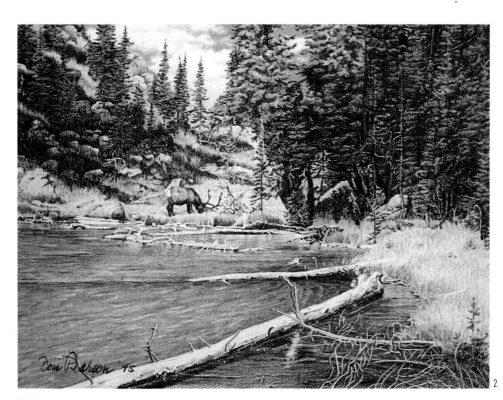

2

Don Pearson
Ouzel Falls
24" x 17" (61 cm x 43 cm)
Strathmore 2-ply paper

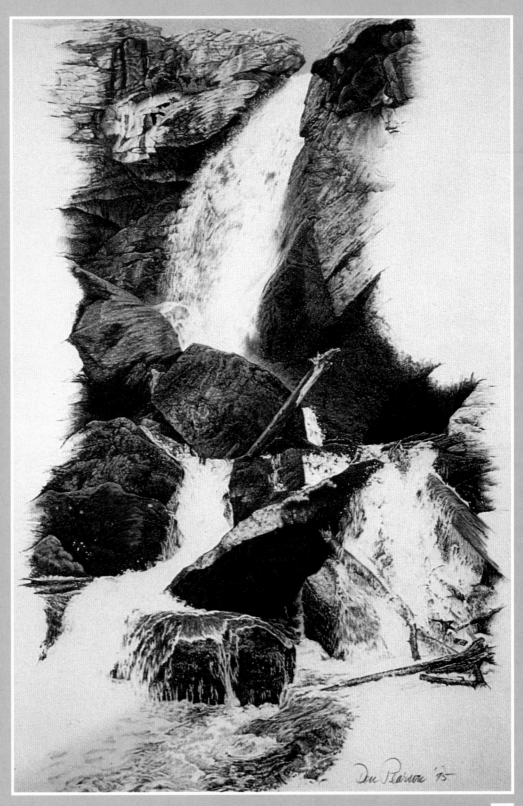

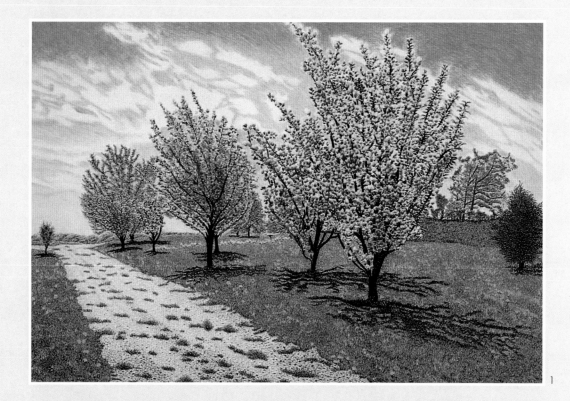

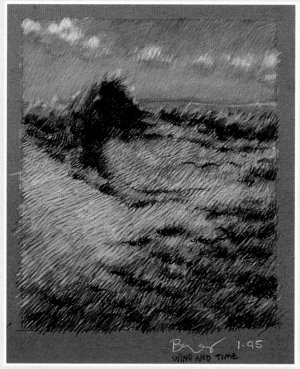

1
Susan McAllister
Roxbury Blossoms
27" x 34" (69 cm x 86 cm)
Strathmore 400 Series

2
Roberta Barnes
Wind and Time
13" x 11" (33 cm x 28 cm)
Crescent acid-free mat board

106

1

Lou Ann McKinney
Choppy Reflections
24" x 32" (61 cm x 81 cm)
Mat board

2

Teresa McNeil MacLean
Top of the Mesa (Montana de Oro)
15" x 18" (38 cm x 46 cm)
Bristol board

3

Teresa McNeil MacLean
How Water Can Fall (Nojoqui Falls)
20" x 14" (51 cm x 36 cm)
Bristol board

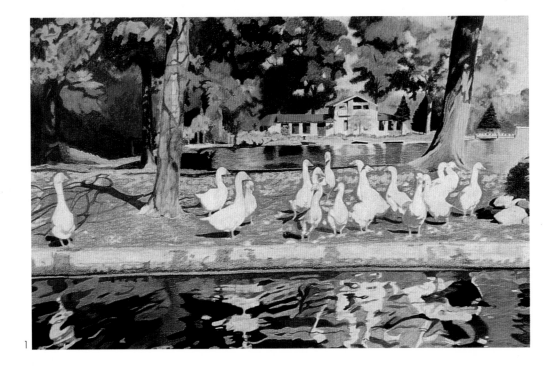

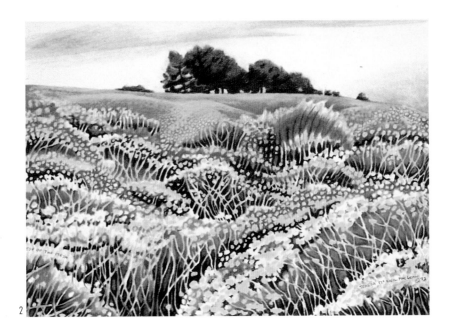

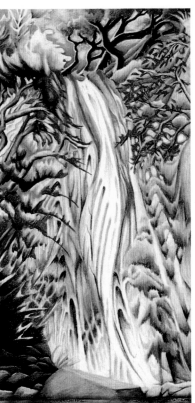

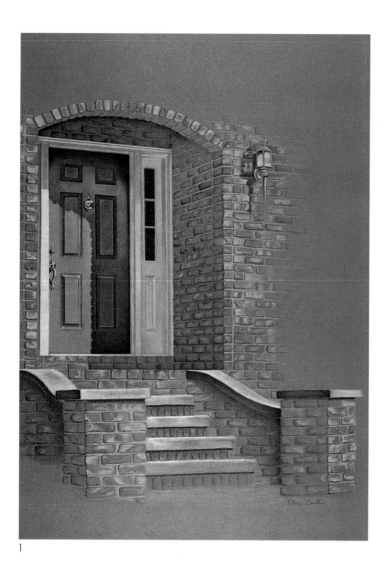

1

Ann L. Curtis
Welcome Home
26" x 24" (66 cm x 61 cm)
Mat board

2

Mary Crowe Dorst
Moonscape with Sapodilla
24" x 22" (61 cm x 56 cm)
Pastel paper, black

1

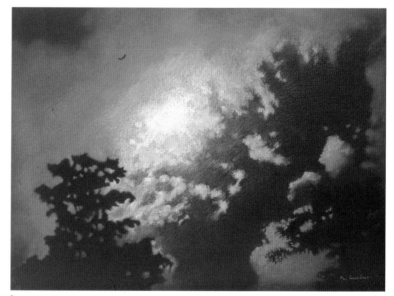

2

1

Mike Pease
Fall Creek
29" x 40" (74 cm x 102 cm)
2-Ply white museum board

2

Priscilla Humay
Badlands Immersion
30" x 37" (76 cm x 94 cm)
Arches hot press 100% rag

3

Carolyn Hudson
Introspection
16" x 10" (41 cm x 25 cm)
Strathmore bristol board 500 Series

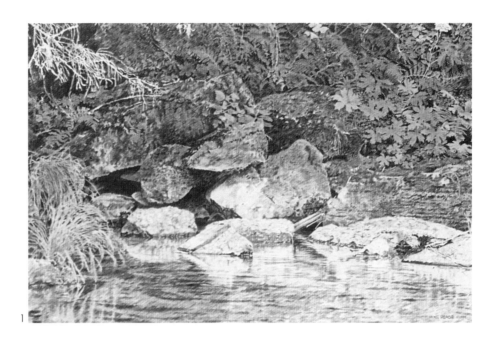

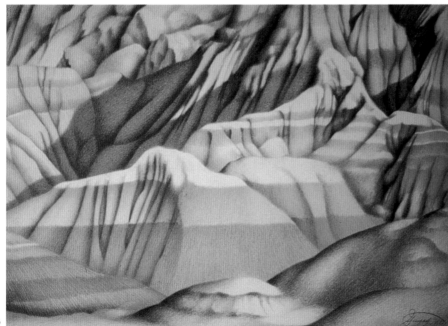

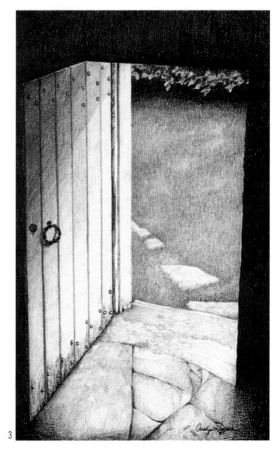

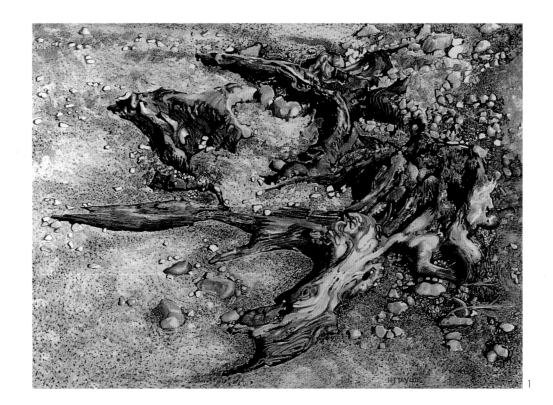

1

1

H. J. Taylor
Sea Sculpture
21" x 24" (53 cm x 61 cm)
Arches 90 lb. smooth

2

Elizabeth Holster
A Stone's Throw
17" x 26" (43 cm x 66 cm)
Arches hot press watercolor paper

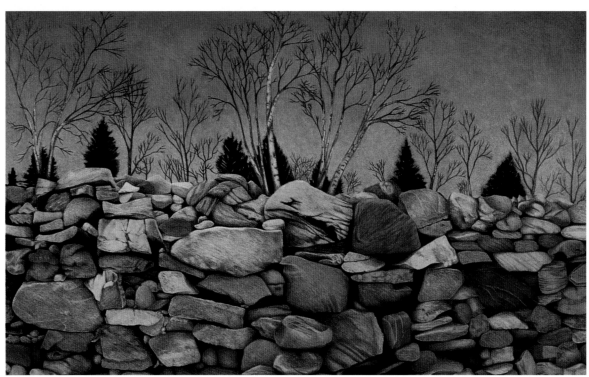

2

Elizabeth Holster
Between a Rock
18" x 26" (46 cm x 64 cm)
Arches hot press watercolor

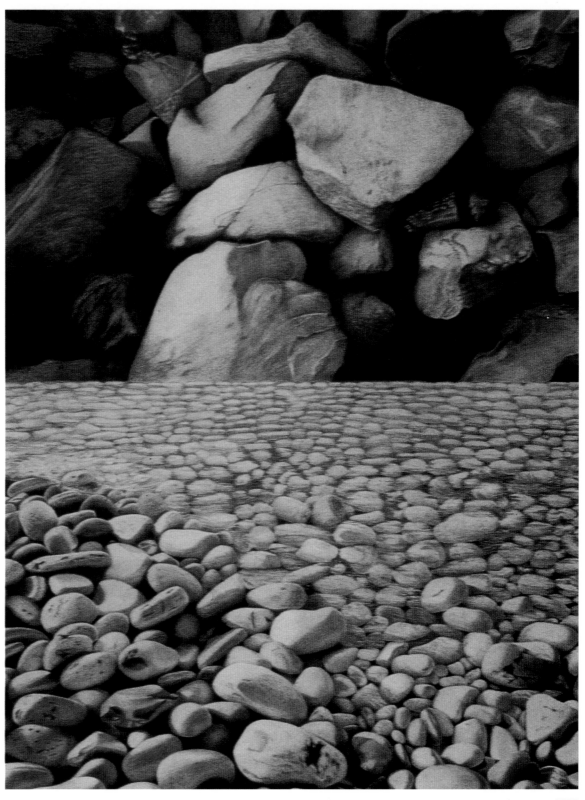

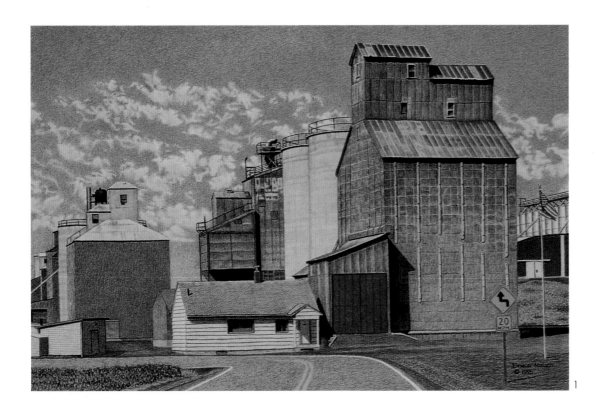

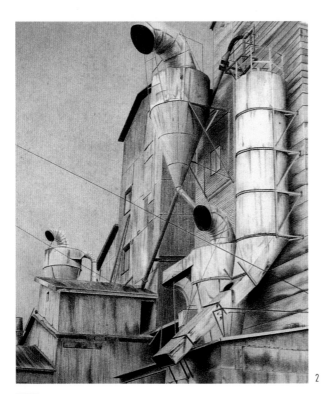

1

Bruce J. Nelson
Wheatland Architecture
15" x 22" (38 cm x 56 cm)
Museum board

2

Ray Haydel
Palouse Pyramids #9
17" x 14" (43 cm x 36 cm)
Vellum

1

Allan Servoss

The Streets Are Quiet Tonight
20" x 25" (51 cm x 64 cm)
Crescent illustration board

2

Valera Washburn

Country Roads
15" x 16" (38 cm x 40 cm)
Museum board

3

Allan Servoss

There is a Story Here
36" x 26" (91 cm x 66 cm)
Crescent illustration board

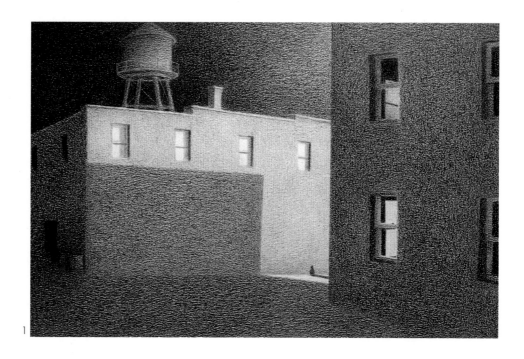

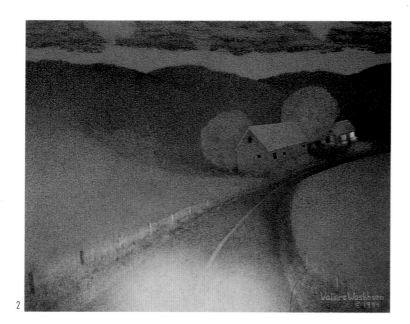

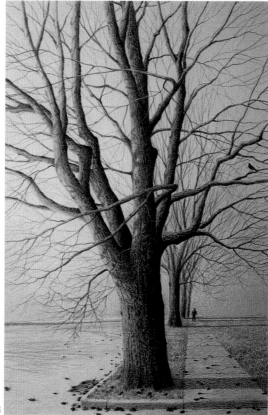

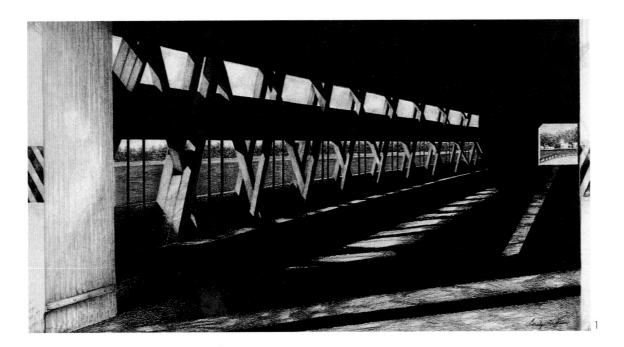

1

Carolyn Hudson
Covered Bridge
21" x 33" (53 cm x 84 cm)
Strathmore bristol board 500 Series

2

Robert W. Sage
Hill Court Apts
20" x 28" (51 cm x 71 cm)
Winsor & Newton cold press
watercolor paper

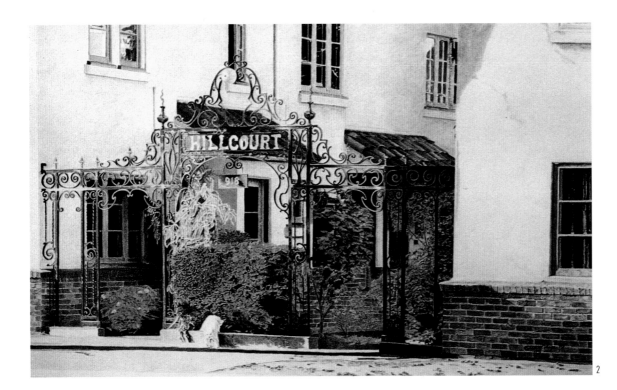

Edna Henry
Village Morning
19" x 14" (48 cm x 36 cm)
Multi-media board

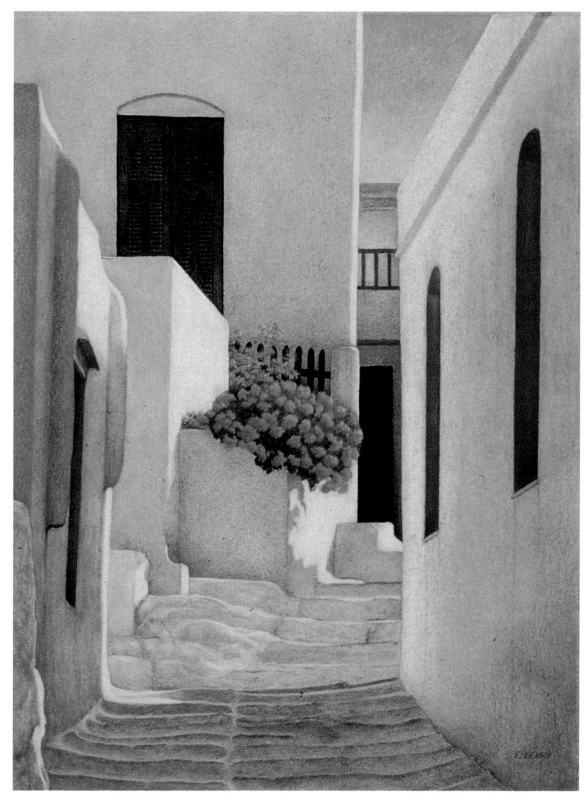

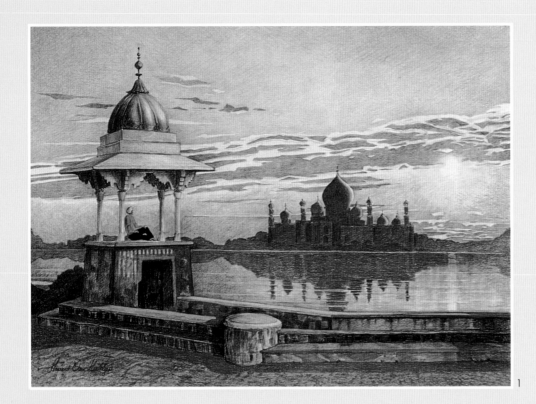

1

Howard Van Heuklyn
Morning Meditation
30" x 36" (76 cm x 91 cm)
Bristol board, smooth

2

Andrea Johnson
Colorado Gold
16" x 12" (43 cm x 30 cm)
Fabriano colored paper

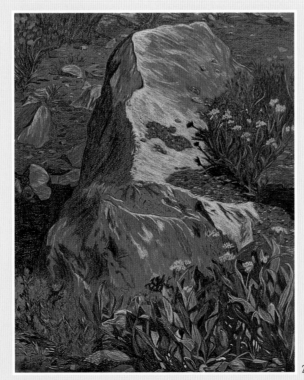

2

1

Pauline A. Braun
Under Clearwater
28" x 36" (71 cm x 91 cm)
Lana Aquarelle 140 lb. watercolor paper

2

Daniel Charles Dempster
Barleycove
16" x 19" (41 cm x 48 cm)
Ingres Arna paper

3

E. Michael Yefko
From Series Clear Cut V
20" x 23" (51 cm x 58 cm)
Meridian drawing paper

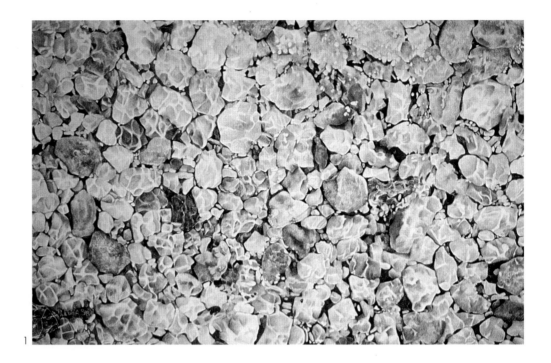

1

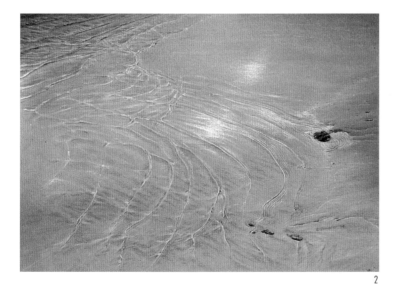

2

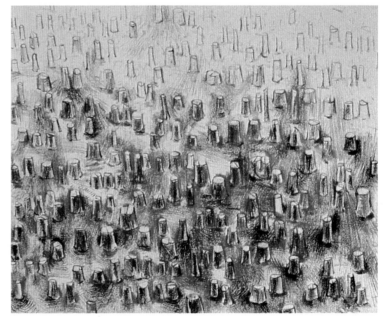

3

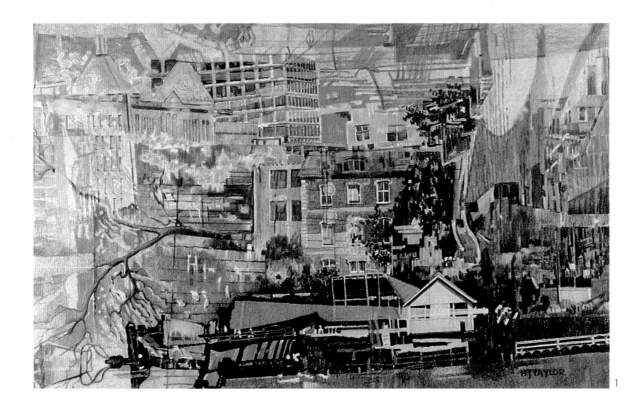

1

H. J. Taylor
Double Exposure
18" x 24" (45 cm x 60 cm)
Arches 90 lb. smooth

2

Donald Leicht
Fire
22" x 28" (56 cm x 71 cm)
Strathmore charcoal paper

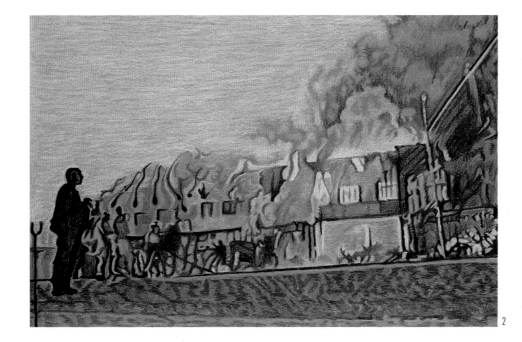

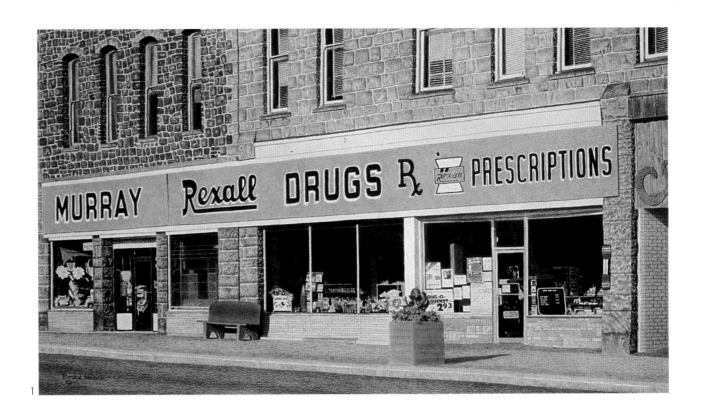

1

Bruce J. Nelson
Life Before WAL-MART
14" x 24" (36 cm x 61 cm)
Rives BFK

2

Norma Samuelson
Rambla, Barcelona, Spain
24" x 18" (61" cm x 46 cm)
Canson, grey

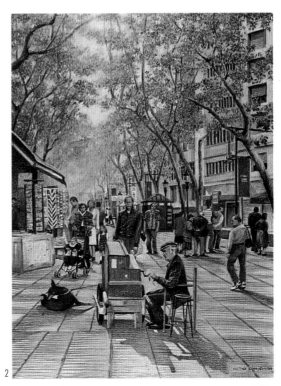

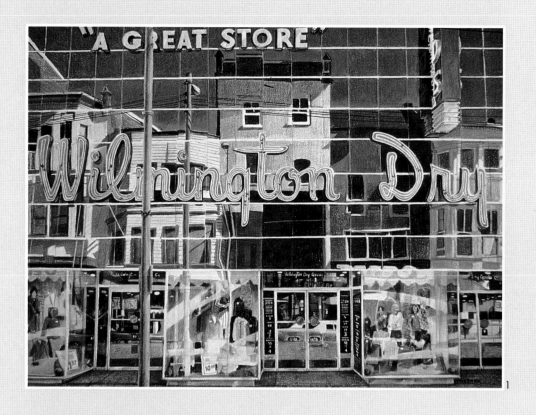

1

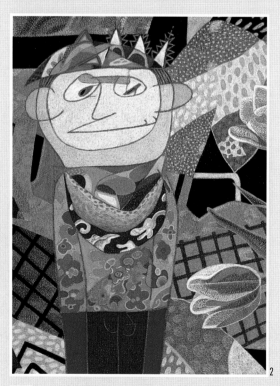

2

1

Leonard Mizerek
Wilmington Dry
20" x 29" (51 cm x 74 cm)
Strathmore hot press 3-ply

2

Barry Steely
Tulip
18" x 15" (46 cm x 38 cm)
Canson Mi-teintes

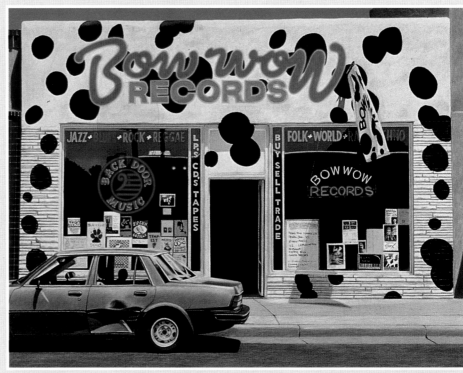

1

Scott Paulk
Doo Wa Ditty
30" x 21" (76 cm x 53 cm)
Strathmore 500 Series

2

Scott Paulk
Dog Gone
15" x 20" (38 cm x 51 cm)
Strathmore 500 Series

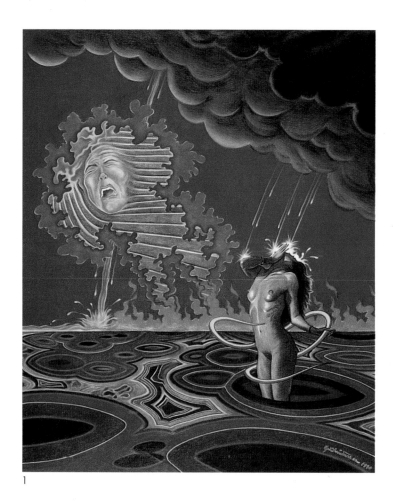

1

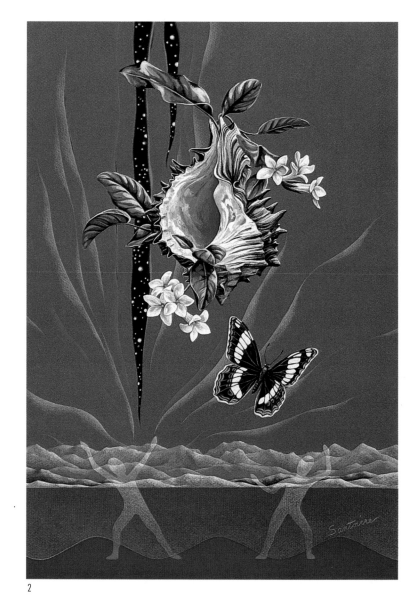

2

Joe Christensen
Quartz Landscape
36" x 32" (91 cm x 81 cm)
Bristol 100 lb. paper

2

Timothy Santoirre
Fall from Grace
28" x 21" (71 cm x 53 cm)
Canson Mi-Tientes

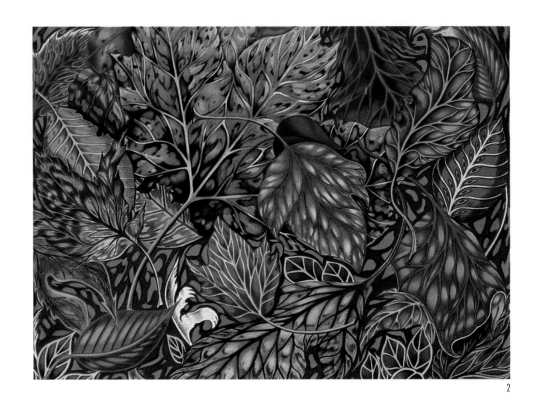

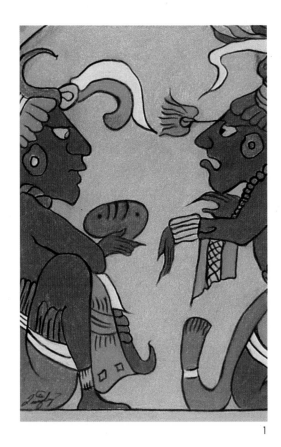

1

Richard Quigley
The Gift
16" x 12" (41 cm x 30 cm)
Rising Stonehenge

2

Susan L. Brooks
Autumn Color
22" x 25" (56 cm x 64 cm)
Rising museum board

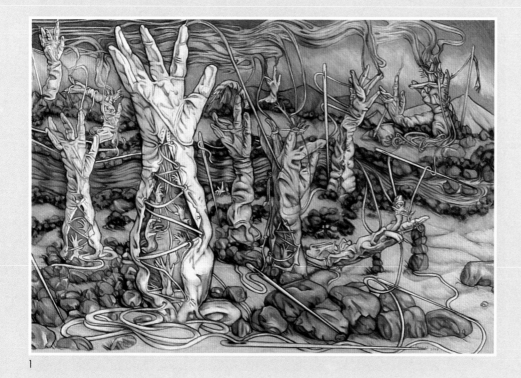

1

Pauline Dove
Future Gardens
28" x 34" (71 cm x 86 cm)
Strathmore 100% cotton

2

Pauline Dove
Stoning Stephen
25" x 18" (64 cm x 46 cm)
Strathmore 100% cotton

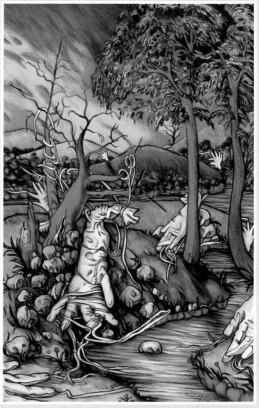

2

1

Meg Behle
ABO Dream-Time
12" x 16" (30 cm x 40 cm)
Crane's stationery

2

Deborah Friedman
A Happy Gulf Day
26" x 36" (66 cm x 91 cm)
Crescent cold press illustration board

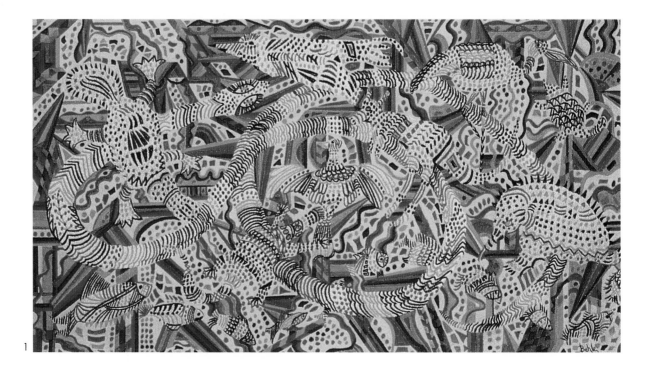

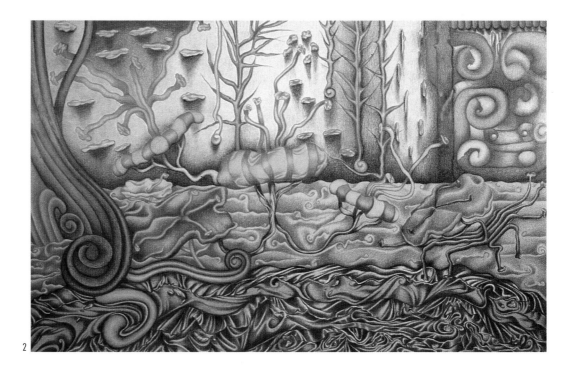

1
Robert M. Sajnovsky
Red Chevy
23" x 29" (58 cm x 74 cm)
Strathmore drawing paper

2
Robert M. Sajnovsky
Rainbow Box
30" x 24" (76 cm x 61 cm)
Strathmore drawing paper

3
Carla McConnell
Cora
21" x 16" (53 cm x 41 cm)
Museum board

1

2

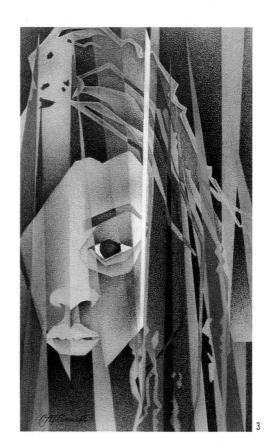

3

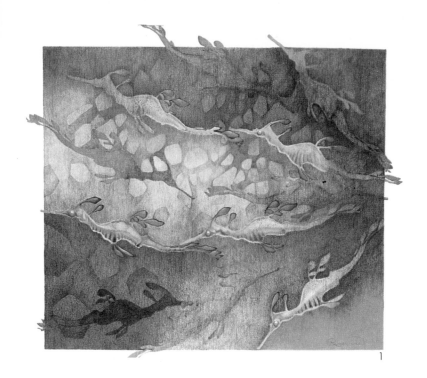

1

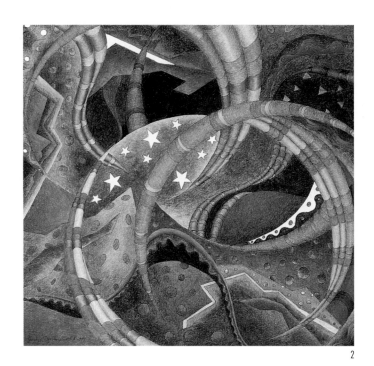

2

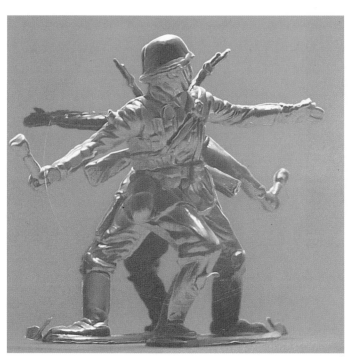

3

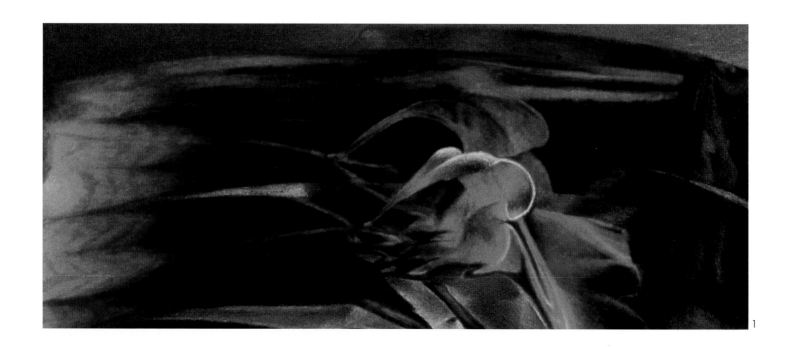

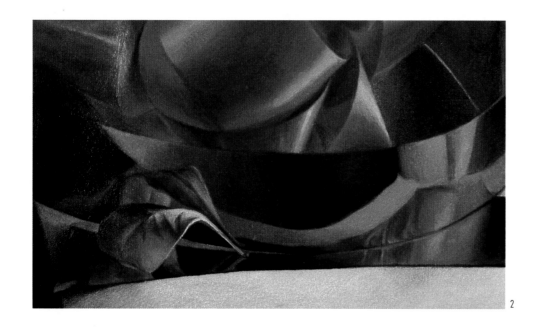

Rosie Hoskins
Red Pool
4" x 8" (10 cm x 20 cm)
Strathmore 400 Series

Rosie Hoskins
Red Reflection
6" x 8" (15 cm x 20 cm)
Strathmore 400 Series

Joe Hyatt
Gumball Machine
16" x 10" (41 cm x 25 cm)
Rising museum board

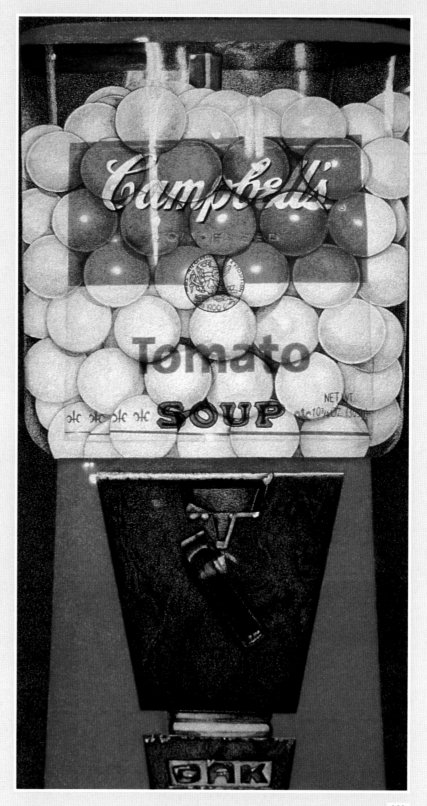

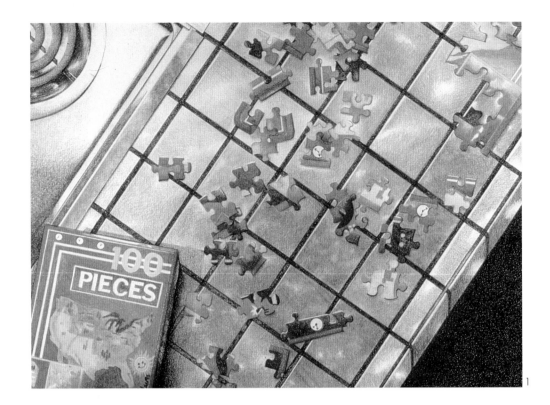

1

Blair Jackson
One Hundred Pieces
28" x 32" (71 cm x 81 cm)
Crescent illustration board

2

Paul Grybow
Y. B. More
23" x 26" (58 cm x 66 cm)
Mat board

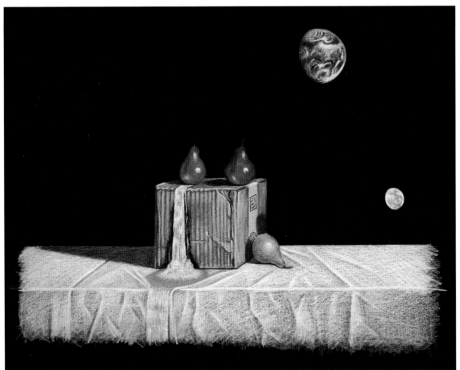

1

Darryl J. Alello
Fall to Pieces
17" x 19" (43 cm x 48 cm)
Medium texture paper

2

Mike Russell
Changing Seasons
20" x 20" (51 cm x 51 cm)
Crescent illustration board

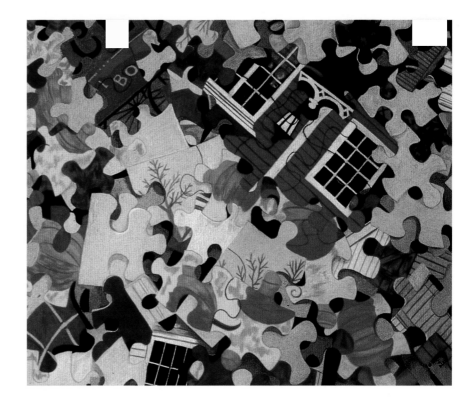

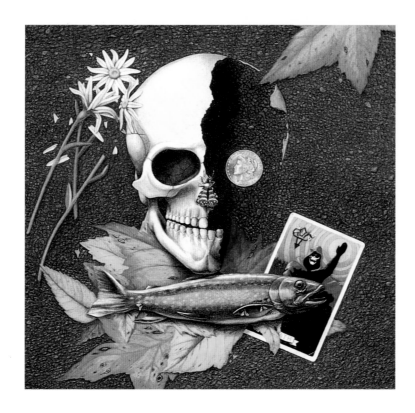

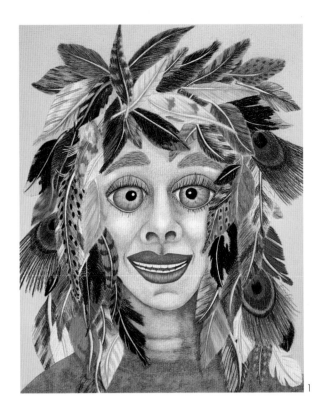

1

3

1
Rhonda Farfan
Feeling A Little Lightheaded
20" x 16" (51 cm x 41 cm)
Rising 2-ply museum board

2
Rhonda Farfan
Not Quite a Full Deck
20" x 16" (51 cm x 41 cm)
Rising Gallery 100

3
Proctor P. Taylor
Impact" x 3
40" x 40" (102 cm x 102 cm)
Strathmore 500 charcoal paper

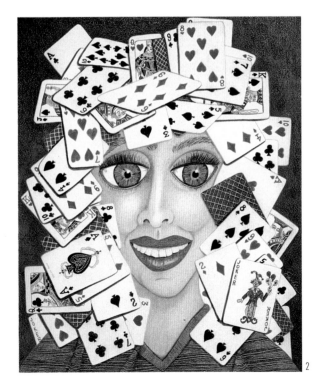

2

1

Vera Curnow
Signature Member
Preyers with Strings Attached
30" x 40" (76 cm x 102 cm)
Crescent acid-free watercolor board

2

Janice G. Rosenthal
Bowling
12" x 11" (30 cm x 28 cm)
Rives BFK

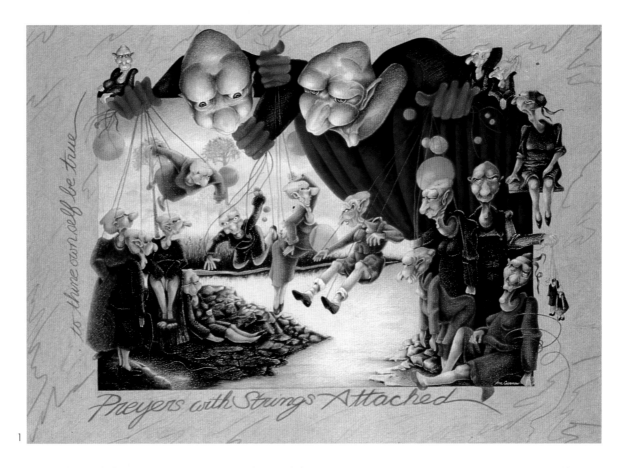

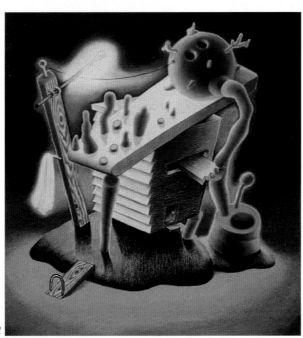

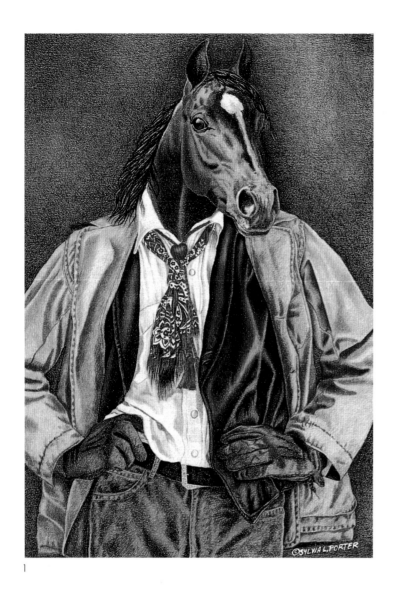

1

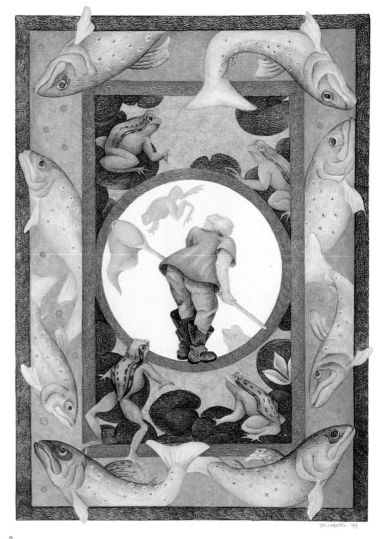

2

1
Sylvia L. Porter
"CALVIN EQUINE" Clotheshorse
24" x 18" (61 cm x 46 cm)
Canson Mi-Tientes

2
Kitty Brumberg
The Fisherman
29" x 23" (74 cm x 58 cm)
Bristol board

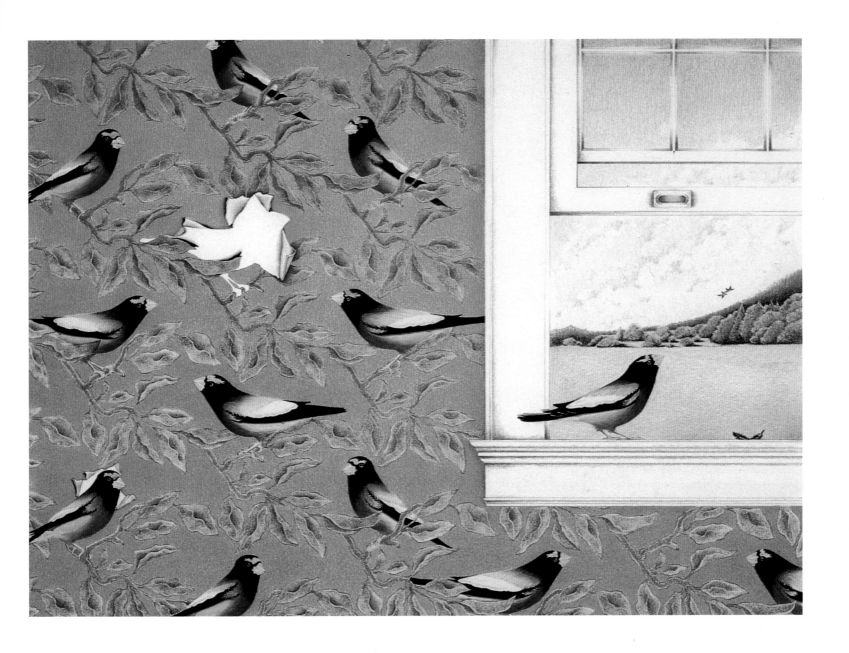

Linda M. Miller
Evening In September
21" x 26" (53 cm x 66 cm)
Rising museum board

135

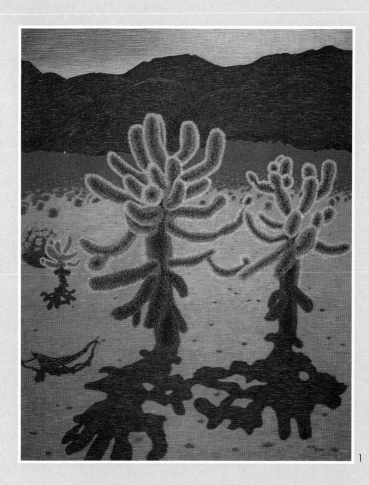

1

Katherine McKay
Anza-Borrego No 9: Cholla
31" x 25" (79 cm x 64 cm)
Canson Mi-Tientes

2

Lula Mae Blocton
Octagon Twist Clear Night
22" x 30" (56 cm x 76 cm)
Rives BFK rag paper

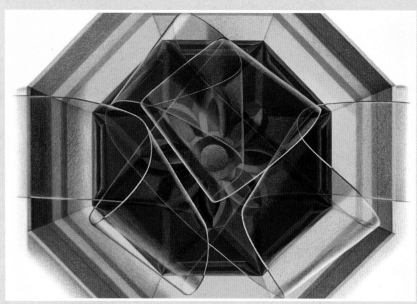

2

1

Mike Russell
Undercover
20" x 20" (51 cm x 51 cm)
Crescent illustration board

2

Colleen R. Black
Complexion
32" x 32" (81 cm x 81 cm)
Black Crescent mat board

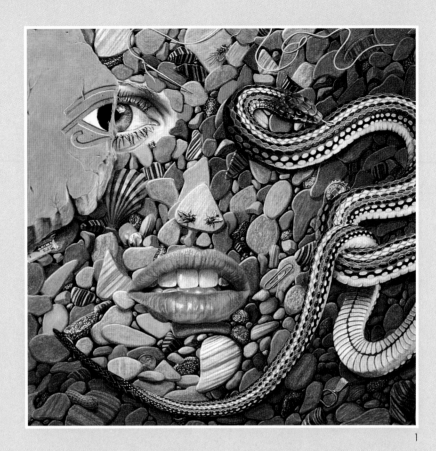

1

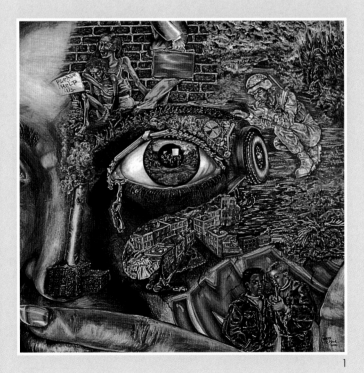

1

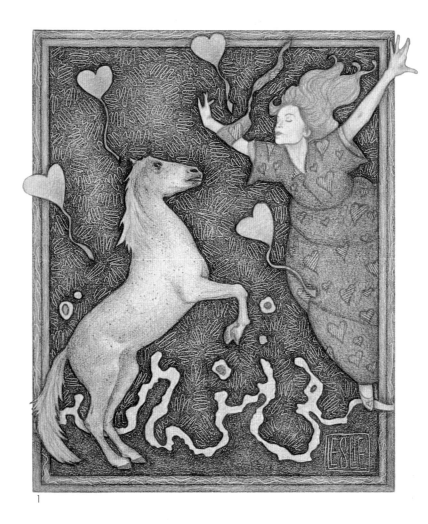

1

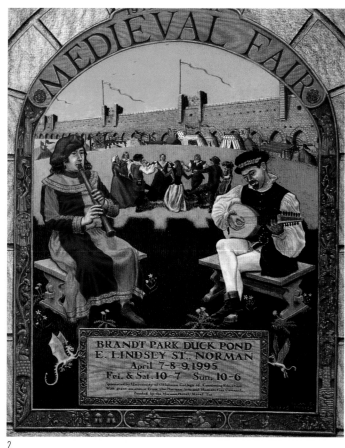

2

1

Leslie Roberts
Dream About the Horse
24" x 22" (61 cm x 56 cm)
2-Ply bristol

2

Susan Elizabeth Musick
Medieval Fair Poster
26" x 20" (66 cm x 51 cm)
Illustration board

Carolyn Reed
Collecting Water
27" x 22" (69 cm x 56 cm)
Rives BFK paper

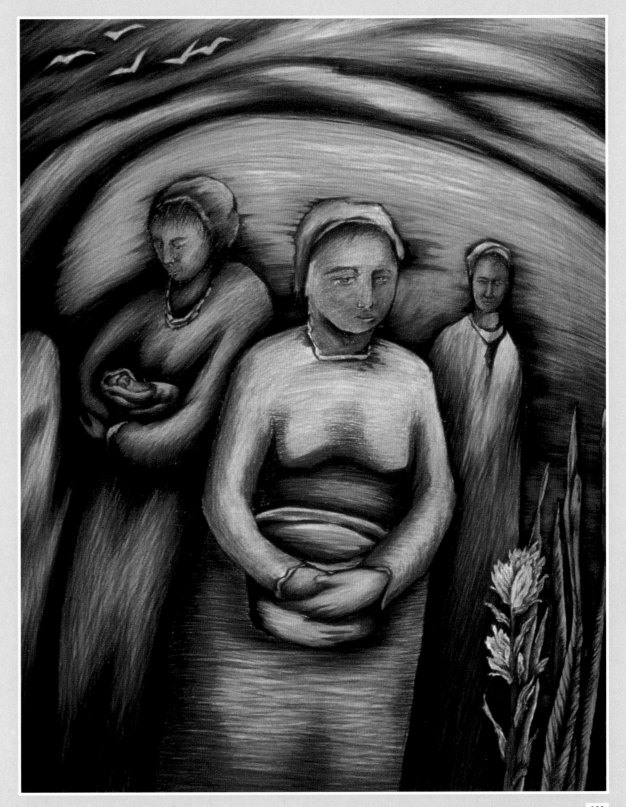

1

Bobbie Bradford
Nine Words
20" x 21" (51 cm x 53 cm)
Canson Mi-Tientes

2

Lee Sims
Crisscross
18" x 18" (46 cm x 46 cm)
Canson Mi-Tientes

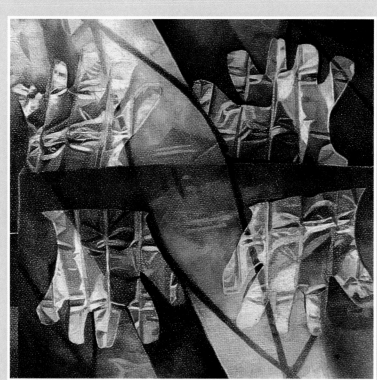

2

1

Jane Shibata
Three Snapshots
14" x 18" (36 cm x 46 cm)
Strathmore museum board

2

Eva Sierzputowski
Turning Line
15" x 20" (38 cm x 51 cm)
100% rag 2-ply paper

1

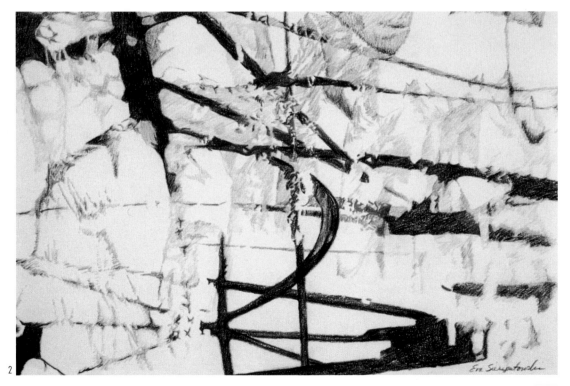

2

141

1

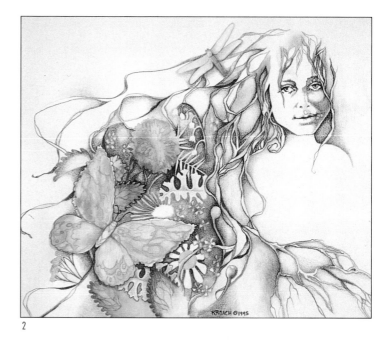

2

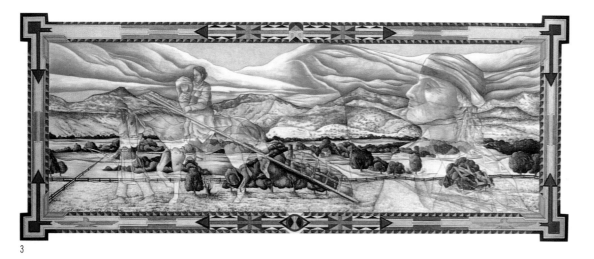

3

1

Rosemary Roach
Summer Dreams
23" x 20" (58 cm x 51 cm)
Bristol plate finish

2

Rosemary Roach
Spring Awakens
23" x 24" (58 cm x 61 cm)
Bristol vellum

3

Alex Graham
Trail of Tears
20" x 44" (51 cm x 112 cm)
Rives BFK 100% rag paper

Richard W. Huck
Still in the Studio with Hippocrates
21" x 13" (53 cm x 33 cm)
Arches hot press paper 240 lb.

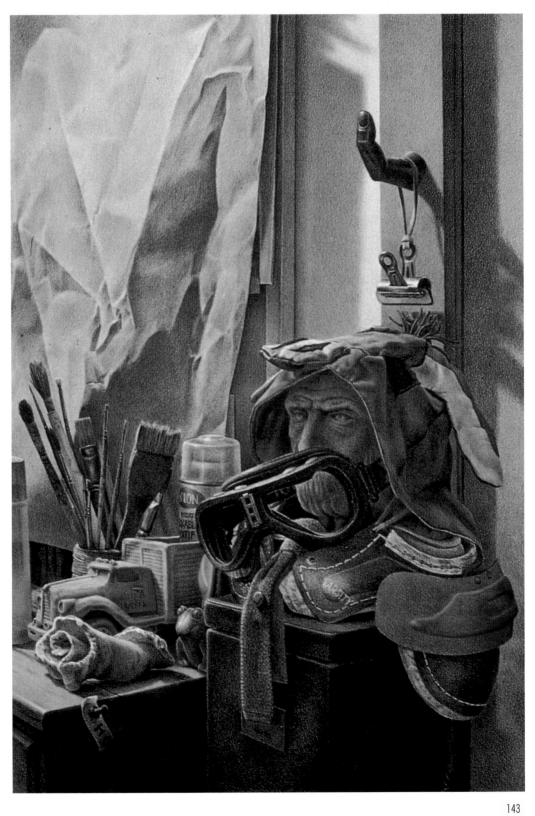

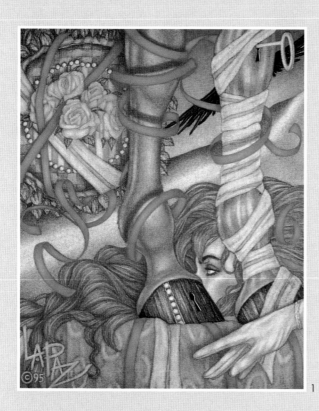

1
Viktoria La Paz
As the Crow Flies
20" x 17" (51 cm x 43 cm)
Crescent illustration board 215

2
Eric Byars
Season's End
14" x 17" (36 cm x 43 cm)
Bainbridge illustration board

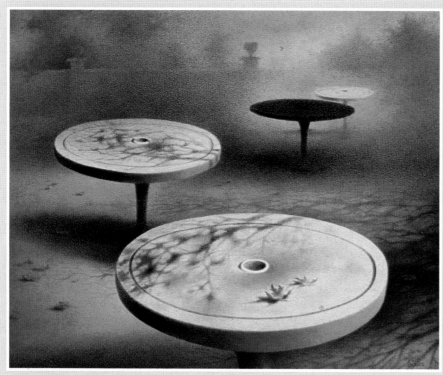

1

Judith Orner Bruce
Burger, Snake, and Fries
14" x 23" (36 cm x 58 cm)
2-Ply rising museum board

2

Eileen S. Bell
Inner Self
19" x 14" (48 cm x 36 cm)
Strathmore 4-ply bristol

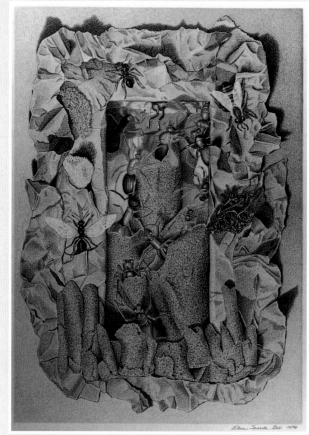

2

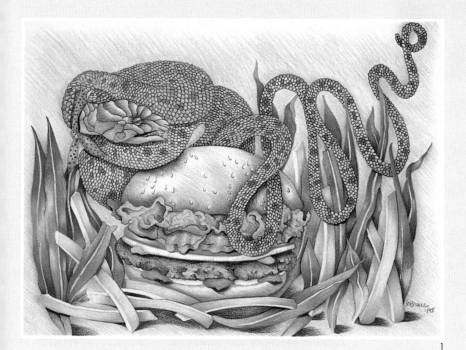

1

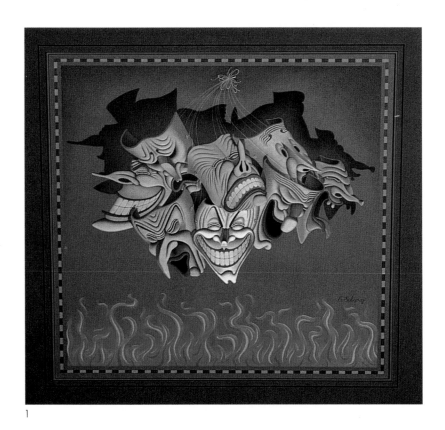

1

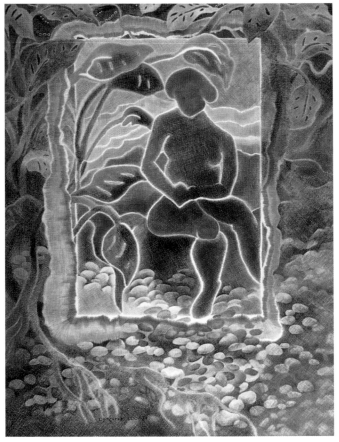

1

Edmond J. Sobieraj
Masks
31" x 32" (79 cm x 81 cm)
Strathmore 400 Series

2

Dyanne Locati
Signature Member
Musing Mattisse II
30" x 22" (76 cm x 56 cm)
Arches hot press

2

1

Sharon Teabo
They Share The Tree
18" x 24" (46 cm x 61 cm)
Bristol 2-ply

2

Timothy Santoirre
The Painter's Muse
19" x 16" (48 cm x 41 cm)
Canson Mi-Tientes

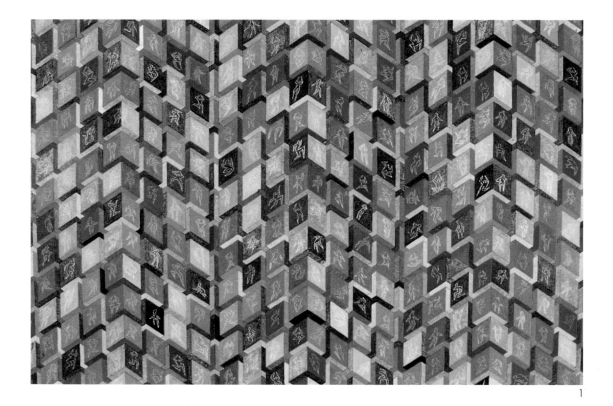

1

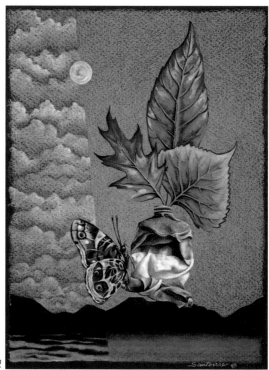

2

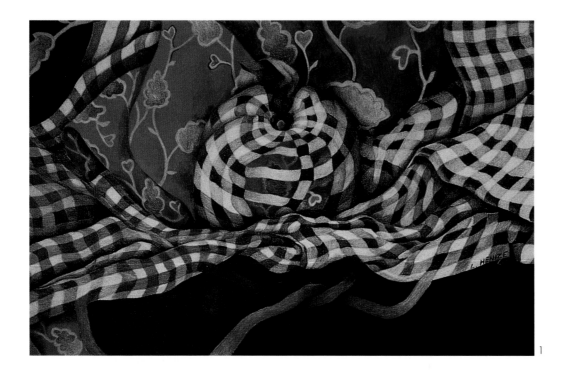

1

Linda Boatman Henize
Gingham Apple
20" x 23" (51 cm x 58 cm)
Rising museum board

2

Barbara Holland
Predator Too
39" x 31" (99 cm x 79 cm)
Crescent mat board, dark blue

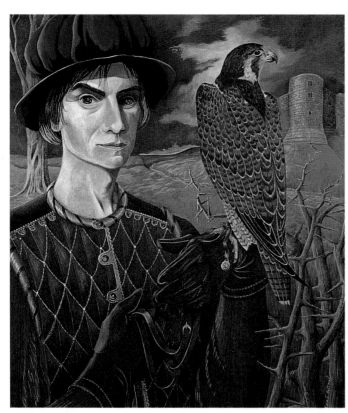

index

● CPSA Signature Members

directory

Ackerman, Deane
117 Snowden St
Sumter SC 29150
803 775-6003

Ackerman, Wendy Nelson
321 Lake Region Blvd
Monroe NY 10950
914 783-4690

Alello, Darryl d.
218 Tate Rd
Denham Springs LA 70726
504 665-6936

Atkinson, Renee Durkee
36260 West Capel Rd
Grafton OH 44044
216 748-3149

Auten, Bonnie
7541 E Monroe Rd
Tecumseh MI 49286
517 423-6184

Averill, Pat
640 Ninth St
Lake Oswego OR 97034-2221
503 635-4930

Baisden, Jeffrey Smart
Rt 7 Box 86
Live Oak FL 32060
904 362-2635

Baker, Carol
32661 Pearl Dr
Fort Bragg CA 95437
707 964-2309

Barnes, Roberta
PO Box 66
Halsey NE 69142
308 533-2552

Bascom, Joe
1550 York Ave
New York NY 10028
212 737-2191

Basile, Donna
PO Box 97
Scituate MA 02066
617 545-1274

Baxter, Linda
13826 S Meyers Rd #2122
Oregon City OR 97045
503 656-4625

Beck, Allison S.
13244 S Leland Rd
Oregon City OR 97045
503 656-4303

Behle, Meg
12948 Angosto Way
San Diego CA 92128
619 487-0135

Belanger, Liliane
452 Rue Dieppe
Ste. Jolie Quebec J3E1C9 Canada
514 922-5552

Belfiglio, Diane
1001 Deborah St NW
N Canton OH 44720
216 494-8459

Bell, Eileen S.
848 Hollyridge
Ballwin MO 63011
314 230-8980

Black, Colleen R.
625 E Portage Trail
Cuyahoga Falls OH 44221
216 945-3347

Blate, Michele K.
1351 Lorrell Ave SE
Canton OH 44720
216 494-3299

Blessing, Betsey
1097 Chandler Rd
Lake Oswego OR 97034
503 635-3297

Blocton, Lula Mae
798 Pudding Hill Rd
Hampton CT 06247
203 455-0820

Bradford, Bobbie
1725 Wilstone Ave
Leucadia CA 92024
619 944-6246

Braun, Pauline A.
PO Box 381
Thompson MB R8N1N2 Canada
204-778-6

Brooks, Susan L.
3760 Versailles Rd
Hoffman Estates IL 60195
708 359-7655

Brown, Janet S.
13320 Callae Dr
Conifer CO 80433
303 838-1263

Brown-Thompson, Rebecca
N 600 Wolf Lodge Creek Rd
Coeur D'Alene ID 83814
208 664-3403

Bruce, Judith Orner
148 N McKinley Pl
Monrovia CA 91016
818 357-1903

Brumberg, Kitty
5 Plymouth Rd
Great Neck NY 11023
516 773-4062

Byars, Eric
RR #4
Flesherton ON NOC1E0 Canada
519 924-3578

Byrem, Lynn A.
324 North Nyes Rd
Harrisburg PA 17112
717 652-0187

Caplan, Frances
7184 Woodrow Wilson Dr
Los Angeles CA 90068
213 876-9749

Cardot-Greiner, Martha
2409 Stratford Rd
Delaware OH 43015
614 363-7699

Chapman, Clare
140 Washington Rd
Woodbury CT 06798
203 266-4004

Cheney-Parr, Leslie
34930 SE Colorado Rd
Sandy OR 97055
503 668-7401

Christensen, Joe
3421 Palmer Dr #221
Cameron Park CA 95682
916 677-5638

Cohen, Davya
7464 Heather Heath Lane
W Bloomfield MI 48322
810 616-0650

Collier, Gail T.
788 Golf Court
Barrington IL 60010
708 382-2741

Conwell, Kathryn
809 NW 41 St
Lawton OK 73505
405 353-7532

Cosentino, Cira
1357 NE Ocean Blvd
Stuart FL 34996
407 225-1389

Coverly, Julie
795 Gluegrass St
Simi Valley CA 93065
805 592-0932

Curnow, Vera
1620 Melrose Ave #301
Seattle WA 98122
206 622-8661

Curtis, Ann L.
4760 Andette Ave NW
Massillon OH 44647
216 833-3530

D'Amico, Luanne
Rt 2 Box 42
Alachua FL 32615
904 462-1261

Dahlgran, Dava
1440 Qattara St
Idaho Falls ID 83404
208 524-2963

Daub, Dorris
519 Manor House Lane
Willow Grove PA 19090
215 659-8601

Davis, Dr. Christine J.
1071 River Rd
Greer SC 29651-8197
803 877-0801

Day, Derryl L.
PO Box 683
Sedona AZ 86339
602 634-2656

DeHaven, Martha
106 La Vista Dr
Los Alamos NM 87544
505 672-3342

Dempster, Daniel Charles
13 Jonquil Lane
Newport News VA 23606
804 930-8215

Dewar, Kay Moore
3056 39th SW
Seattle WA 98116
206 935-2634

Dorst, Mary Crowe
618 NW High St
Boca Raton FL 33432
407 395-4918

Dove, Pauline
4001 Irvington Dr
Charlotte NC 28205
704 568-1506

Drayton, Richard
85 Highland Dr S
Sedona AZ 86351
520 284-9125

Egging, Cynthia J.
12155 Rd 38
Gurley NE 69141-6511
308 884-2305

Ernst, Tim
Maison Ishikawa B-302, 16-26
Yabase Shinkawamukai Akita-shi,
Akita-Ken 10 Japan
81-0188 63-7253

Fagan, Allison
40 Drainie Dr
Kanata ONT K2L2J9 Canada
613 692-6959

Farfan, Rhonda
25318 Ferguson Rd
Junction City OR 97448
503 998-3608

Fleischer, Chere
1022 Meadowlark Lane
Cottonwood AZ 86326
520 639-0536

Fleming, Rob
PO Box 53
Driftwood TX 78619
512 858-7851

Flynn, Katharine
PO Box 2396
Sedona AZ 86339
520 282-1263

Forscey-Milledge, Judith
4976 Potter Rd
Mayville NY 14757-9634
716 753-7579

Freidel, Judy A.
2382 Hwy 7 North
Hot Springs AR 71909
501 623-1139

Friedman, Deborah
6907 Pebble Creek Woods Dr
W Bloomfield MI 48322
810 626-3729

Gaby, Sari
315 Oxford St #1
Rochester NY 14607
716 288-7870

Garcia, Nancy
3156 Holmes Run Rd
Falls Church VA 22042
703 533-2805

Gardner, Susan Lane
1320 4th St
Columbia City OR 97018
503 366-0959

Garrabrandt, Bruce S.
1505 Newport Dr
Lakewood NJ 08701
908 367-4223

Gawron, Nancy
32 Delaware Ave
Red Bank NJ 07701
908 741-7523

Gaylord, Donna
1980 W Ashbrook
Tucson AZ 85704
520 297-6257

Geissbuhler, Stefan
10854 W Evans Ave
Lakewood CO 80227
303 986-5094

Gerard, Jim
618 Troy Ct
Mentor OH 44060
216 255-4134

Gildow, Janie
905 Copperfield Lane
Tipp City OH 45371
513 335-8460

Graham, Alex
1516 Breeze Canyon Dr
Las Vegas NV 89117
702 363-3286

Greene, Gary
21820 NE 156th St
Woodinville WA 98072
206 788-2211

Greene, Linda
10081 Mavarre Rd SW
Navarre OH 44662
216 879-2845

Grybow, Paul
387 Rochester
Costa Mesa CA 92627
714 646-7941

Guthrie, Robert
3 Copra Lane
Pacific Palisades CA 90272
310 454-7533

Haas, Susan E.
Mount Morris Star Rt
Waynesburg PA 5370
412 627-8066

Hamlin, Linda Jo
1117 W St George Ave
Ridgecrest CA 93555
619 375-3435

Hansen, D. J.
3501 Janes Rd
Arcata CA 95521
707 822-6303

Harvey, Tanya
40237 Reuben Leigh Rd
Lowell OR 97452-9712
503 937-1401

Haydel, Ray
PO Box 3494
Moscow ID 3843
519 332-6703

Heath-Rawlings, Beverly
2411 Sourek Rd
Akron OH 44333-2928
216 864-1183

Heller, Cathy
13003 Montpelier Ct
Woodbridge VA 22192
703 494-6474

Henize, Linda Boatman
23009 S Frances Way
Channahon IL 60410
815 467-2705

Henry, Edna
29650 SW Courtside Dr #14
Wilsonville OR 97070
503 682-8853

Hershberge, Carlynne
1016 NE 3rd St
Ocala FL 34470
904 622-4943

Hershenson, Kenneth
PO Box 2925
Port Angeles WA 98362
360 457-9280

Hill, Mike
2509 San Marcus
Dallas TX 75228
214 328-7525

Hobbs, Mary G.
65 Carriage Stone Dr
Chagrin Falls OH 44022
216 247-4275

Holland, Barbara
104 Janet Kay Dr
Longview TX 75605
903 663-1039

Hollingsworth, Joan C.
2824 NE 22 Ave
Portland OR 97212
503 287-6439

Holmberg, Norman
141 Washington Ave S #1405
Minneapolis MN 55401
612 359-9926

Holster, Elizabeth
727 East "A" St
Iron Mountain MI 49801
906 779-2592

Hoskins, Rosie
391A Oak St #2
Columbus OH 43215
614 221-1784

Huck, Richard W.
615 W Marion St
Lancaster PA 17603
717 392-1214

Hudson, Carolyn
2630 Parkwyn
Kalamazoo MI 49008
616 382-4506

Humay, Priscilla
PO Box 148
Gurnee IL 60031
708 360-8555

Hunter, Suzanne
6752 Fiesta
El Paso TX 79912
915 584-1074

Hutchins, Vivian Mallette
9797 E Nicaragua Pl
Tucson AZ 85730
520 721-9411

Hutchinson, Linda
1784 Tallmadge Rd
Kent OH 44240
216 673-3884

Hyatt, Joe
4500 Opal Cliff Dr
Santa Cruz CA 95062
408 479-9049

Hyback, Susan Fulghum
4875 Owen Rd
Memphis TN 38122-4254
901 682-4099

Jackson, Blair
6318 Waterway Dr
Falls Church VA 22044
703 642-0937

James, D. Thornburg
6700 E 6th Ave Pkw
Denver CO 80220
303 355-1553

Jigarjian, Denise
859 Applewilde Dr
San Marcos CA 92069
619 736-0040

Johnsen, Michele
RR 1 Box 328A
Colebrook NH 03576
603 237-5500

Johnson, Andrea
PO Box 3216
Vista CA 92085
619 967-2812

Kaiser, Caroline
100 Vaughn Rd Apt #20
Toronto ON M6C2M1 Canada
416 651-1256

Kerr, Kathy
247 NE Lincoln
Hillsboro OR 97124
503 640-4330

Kline, Jill
342 Whetstone #6
Marquette MI 49855
906 228-2769

Kritzberg, Susan
PO Box 47
Yorkville IL 60560
708 553-5835

Kullberg, Ann
31313 31 AV SW
Federal Way WA 89023
206 838-4890

Kutch, Kristy A.
11555 W Earl Rd
Michigan City IN 46360
219 874-4688

La Paz, Viktoria
2135 NW Flanders St
Portland OR 97210
503 497-1252

Leicht, Donald
204 Pecan St
Jacksonville FL 32211
904 721-8317

Lenhart, Crystal
1736 North Heights Dr
Sheridan WY 82801
307 672-6926

Lindstedt, Doreen
3016 NE 59th
Portland OR 97213
503 249-0046

Locati, Dyanne
6720 Doncaster Dr
Gladstone OR 97027
503 659-6904

MacLean, Teresa McNeil
PO Box 1091
Santa Ynez CA 93460
805 688-8781

Madawick, Paula
159 Piermont Ave
Piermont NY 10968
914 359-2597

Marciniak, Sylvia
20001 E Williams Ct
Grosse Pointe Woods MI 48236
313 881-2907

Mart, Susan
1901 N. Dayton
Chicago, IL 60614
312 528-0022

Massey, Ann James
4, Rue Auguste
Chabrieres Paris France 011-331
42507245

Matz, Marguerite Dailey
207 Alden Rd
Carnegie PA 15106
412 276-0806

McAllister, Susan
1415 Stannage Ave
Berkeley CA 94702
510 525-4375

McCarty, Ruth
629 Crestview Dr
Corunna MI 48817
517 743-4372

McConnell, Carla
729 W Broadway
Montesano WA 98563
360 249-4810

McKay, Katherine
PO Box 5472
Richmond CA 94805
415 477-4739

McKinney, Lou Ann
164 Ledgewater Dr
Akron OH 44319
216 644-3396

McLain, Gail
43 Bluegrass Lane
Sequim WA 98382
360 683-5078

Miller, Linda M.
1642 NE 127th Ave
Portland OR 97230
503 252-4281

Miller, Vera Susan
7212 Fairbanks Ave
Chattanooga TN 37343
615 843-3387

Mizerek, Leonard
35 Edgewater Hillside
Westport CT 06880
212 689-4885

Morse, Susan
1686 Crest Rd
Cleveland Heights OH 44121
216 381-8919

Musick, Susan Elizabeth
727 N. Lahoma Ave.
Norman, OK 73069
405 360-0125

Myers, Claudia M.
3521 Culver DR NW
Canton OH 44709
216 492-7877

Nece, Melissa Miller
2245 D Alden Lane
Palm Harbor FL 34683-2533
813 786-1396

Nelson, Bruce J.
461 Avery Rd E
Chehalis WA 98532-8427
360 262-9223

Newton, Barbara
17006 106th Ave SE
Renton WA 98055
206 271-6628

Nutter, Randy
6906 Chartwell Ct
Louisville KY 40241
502 327-9796

O'Neal, Tim
120 Pleasantview
Hamilton IL 62341
217 847-3280

Ogan, Margaret J.
16215 SE Whipple Lane
Milwaukie OR 97267
503 652-6887

Orsini, Anita
6721 NW 27th Way
Fort Lauderdale FL 33309
305 968-3762

Ospanik, Laura
1150 Kaahanui Pl
Lahaina HI 96761
808 661-8718

Parks, Alma L.
465 S Hometown Rd
Copley OH 44321-1203
216 668-2408

Paulk, Scott
504 Brooktree Rd
Knoxville TN 37919
615 690-1064

Pawelczyk, Stanley
306 Monroe Dr
Piedmont SC 29373
803 269-7782

Pearson, Don
7819 S College Pl
Tulsa OK 74136
918 492-8008

Pease, Mike
3145 Whitten Dr
Eugene OR 97405
503 345-8819

Peters ,Cheryl
9475 S Mattoon Rd
Estacada OR 97023
503 631-2164

Pikar ,Edward
2930 Spring Grove
Cincinnati OH 45225
513 542-6568

Pinciotti, Michael Rocco
29 John St Apt 1108
New York NY 10038
212 285-0959

Pohlmann, Mary
15398 NE 2nd Ave
Miami FL 33162
305 945-8570

Porter, Sylvia L.
817 Spring Dr
Arlington TX 76012
817 261-6803

Quigley, Richard
2260 Jefferson
Eugene OR 97405
503 344-2962

Reed, Carolyn
PO Box 198
Unalaska AK 99685
907 581-2316

Reeder, Karne Emerald
PO Box 2288
Ruidoso NM 88345
505 258-5673

Rich, Lonnie
Rt 6 Box 281-A
Andalusia AL 36420
334 388-4755

Rimerman, Jan
PO Box 1350
Lake Oswego OR 97035
503 635-3583

Roach, Rosemary
709 N 102nd
Seattle WA 98133
206 782-6273

Roberts, Leslie
13558 Rye St #4
Sherman Oaks CA 91423
818 995-3907

Robinson, Linda Faulkner
8529 Stonebridge Ave NW
N Canton OH 44720
216 499-3934

Rocha, Gilbert
153 Hillcrest Dr
N Platte NE 69101
308 534-4623

Rochelle, Carolyn
6186 SE Nelson Rd
Olalla WA 98359
206 857-4857

Rolland, Dawn
255 Eighth St Apt #32
Jersey City NJ 07302
201 420-0502

Rosenthal, Janice G.
1539 Woodcrest Dr
Reston VA 22094
703 709-7735

Russell, Mike
427 1st St
Brooklyn NY 11215
718 499-3436

Sagasti, Miriam
2441 Sedgefield Dr
Chapel Hill NC 27514
919 942-9839

Sage, Robert W.
2037 Oxford St
Sacramento CA 95815
916 927-2277

Samuelson, Norma
24392 Chrisanta
De Mission Viejo CA 92691
714 587-9046

Samul, Cynthia
15 Pacific St
New London CT 06320
203 442-5695

Sands, Elly
PO Box 1597
Sedona AZ 86339
520 284-0205

Santoirre, Timothy
1412 Morrison St
Madison WI 53703
608 259-1117

Schwemmer, Barbara E.
22 Coronado Shores
Lincoln City OR 97367
503 764-2417

Sciko, Terry
1450 Bonnie Rd
Macedonia OH 44056
216 467-1259

Servoss, Allan
3540 Parkside Circle W
Eau Claire WI 54701
715 832-1758

Shibata, Jane
2024 Purdue Ave
Los Angeles CA 90025
310 477-1817

Shoup, Robin
866 Alexander Rd
Bellville OH 44813
419 886-2310

Sierzputowski, Eva
1366 W 59th St
Cleveland OH 44102-2102
216 651-1545

Simonson, Gale
10301 Tennyson Ct
Westminister CO 80030
303 460-7586

Sims, Lee
735 Ridge Rd
Lansing NY 14882
607 533-7024

Skoczen, Rita Mach
609 Spartan Dr
Rochester Hills MI 48309
810 651-8538

Smith, Anne Renard
PO Box 188
Burgess, VA 22432
804 453-4303

Smith, Dixie
25601 16th Ave S
Kent WA 98032
206 941-9053

Smith, Sherry L.
4710 Hersand Ct
Woodbridge VA 22193
703-680-5078

Snowman, Tracy D.
RR #5 Box 338B
Canton IL 61520
309 647-0569

Sobieraj, Edmond J.
703 Huron Rd
Cleveland OH 44115
216 696-7926

Steely, Barry
834 President St
Brooklyn NY 11215
718 857-0398

Stewart, Shelly M.
PO Box 296
Albion WA 99102
509 332-8926

Stripling, Iris
4610 Somerset CT
Kent WA 98032
206 854-5704

Swarts, Jeannine
3741 S Sunnyfield Dr
Copley OH 44321
216 666-9639

Swiech, Cindy Mis
2782 First St
Eden NY 14057
716 992-4153

Synoground, Kaye
3636 SW Canby St
Portland OR 97219
503 293-3249

Taylor, H. J.
351 Le Burel Pl
Brentwood Bay BC V8M1G8
Canada
604 652-5249

Taylor, Melissa
33 WN Broadway
Columbus OH 43214
614 263-6237

Taylor, Proctor P.
121 Valentine Dr
Long Beach MS 39560
501 863-4669

Teabo, Sharon
115 Virginia Ave
Petersburg WV 26847
304 257-4634

Tennent, Jeanne
1010 Puritan
Birmingham MI 48009
810 647-1115

Toole, Maggie
3655 Colonial Ave.
Los Angeles CA 90066
310 398-4587

Tooley, Richard
1281 W Wood St
Decatur IL 62522
217 423-2961

Triguba, Marvin
1463 Rainbow Dr NE
Lancaster OH 43130
614 687-1338

Van Heuklyn, Howard
240 N Orange Grove Blvd
Pasadena CA 91103-3536
818 796-7294

Vestin, Diane Donicht
269 Crosby Rd
Cloquet MN 55720
218 879-6915

Wadler, Ronni
8 Mardon Rd
Larchmont NY 10538
914 834-2116

Walker, Joy Rose
1280 Williamson Creek Rd
Pisgah Forest NC 28768
704 877-4827

Walker, Norah C.
821 Front Ave
Coeur D'Alene ID 83814
208 667-0249

Ward-Donahue, Beth
1228 E Brooks Rd
Midland MI 48640
517 631-1498

Warner-Ahlf, Kristin
PO Box 241
S. Cle Elum WA 98943-0241
509 674-5759

Washburn, Valera
4175 SW Crestwood Dr
Portland OR 97225
503 291-7018

Webster, Jennifer Phillips
505 Sixth Ave
Radford VA 24141
703 731-9368

Wells, Jim
5801 Woodburn Dr
Knoxville TN 37919
615 584-8954

Welsher, Phil
27 Sturwood Dr
Belle Mead NJ 08502
908 874-0959

Wesner, Linda
2834 Honey Tree Dr
Germantown TN 38138
901 753-6524

West, Susan Y.
5840 Hwy. 215
Pauline SC 29374
803 573-9847

Westberg, Bruce Martin
406 7th Ave S
Wausau WI 54401
715 842-8809

Westlake, Laura
129 Weaver Rd
West Sayville NY 11796
516 567-6832

Whitener, Dena V.
1986 Kramer Way NE
Marietta, GA 30062
404 565-5517

Wickey, Faith
901B Monroe Circle NE
Atlanta GA 30308
404 875-3815

Winkler, Lilliam
16854 Charmel Lane
Pacific Palisades CA 90272
310 454-5168

Wiseman, Christine
1042 Hwy 2 Apt F
Wrightwood CA 92397
619 249-6474

Woggan, Brenda J.
8785 Sanbur Trail NW
Rice MN 56367
612 393-2709

Wollam, Larry D.
2055 Miraval Quinto
Tucson AZ 85718-3005
520 299-2714

Wong, Joe
705 Vallejo St #31
San Francisco CA 94133
415 788-9709

Wood, Joanne Smith
2020 Evergreen Ave
Salt Lake City UT 84109
801 272-9626

Yaun, Debra Kauffman
5271 Fraser Rd
Buford GA 30518
404 932-2710

Yefko, E. Michael
206 Widow Sweets Rd
Exeter RI 02822
401 295-1068

Zenner, Sidne
18761 SW Indian Creek Way
Lake Oswego OR 97035
503 620-9433

Zonker, Kenneth L.
703 Ave J
Huntsville TX 77340
409 295-8320